THE GREAT WESTERN

—— VOLUME TWO ——

BRISTOL TO PLYMOUTH

Stanley C. Jenkins & Martin Loader

AMBERLEY

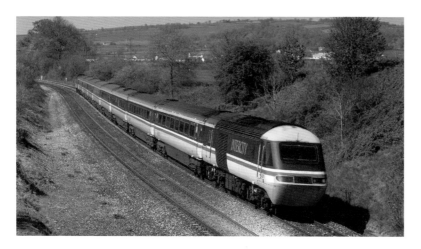

A High Speed Train on Wellington Bank

An eastbound HST set headed by power car No. 43171 climbs towards Whiteball Summit with the 9.35 a.m. Plymouth to Paddington service on 2 May 1994.

ACKNOWLEDGEMENTS

Thanks are due to Mike Marr (pages 10, 11, 32, 56, 69, 70, 74, 79, 82, 85 & 112) for the supply of photographs used in this book. Other images were obtained from the Lens of Sutton Collection, and from the authors' own collections. Thanks are also due to Chris Turner for the loan of GWR timetables and other contemporary documents.

A Note on Distances

The distances quoted in relation to stations or other infrastructure are based upon the milepost distances, which are measured in miles and chains from Paddington (1 mile = 1,760 yards and 1 chain = 22 yards). There are 80 chains to the mile.

First published 2014

Amberley Publishing
The Hill, Stroud, Gloucestershire, GL5 4EP
www.amberley-books.com

Copyright © Stanley C. Jenkins & Martin Loader, 2014

The right of Stanley C. Jenkins & Martin Loader to be identified as the Authors of this work has been asserted in accordance with the Copyrights, Designs and Patents Act 1988.

ISBN 978 1 4456 3942 0 (print)
ISBN 978 1 4456 3954 3 (ebook)

British Library Cataloguing in Publication Data.
A catalogue record for this book is available from the British Library.

Typesetting by Amberley Publishing.
Printed in Great Britain.

INTRODUCTION

The first section of the Great Western Railway (GWR) was ceremonially opened between Paddington and Maidenhead on 31 May 1838, while public services commenced on Monday, 4 June 1838. The new line was 22 miles 42 chains in length, and built to the broad gauge of 7 ft ¼ inches. The railway was extended westwards to Twyford on 1 July 1839, and to Reading on 30 March 1840.

Meanwhile, at the western end of the GWR route, work was well under way at Bristol, where the authorised terminus at Temple Meads would be built on a series of arches some 15 feet above ground level. The works at the Bristol end of the line were well advanced by the early months of 1840 and, following a trial trip on 21 August, the directors decided that the section between Bristol Temple Meads and Bath would be opened on Monday, 31 August 1840. The first train was hauled by 'Firefly' class 2-2-2 locomotive *Fireball*, and it consisted of three first-class and five second-class carriages filled by the general public.

THE BRISTOL & EXETER RAILWAY

Although the GWR main line terminated at Bristol, it was envisaged that the broad gauge system would be extended westwards by companies such as the Bristol & Exeter Railway (B&ER). B&ER was sanctioned by parliament on 19 May 1836, with powers for the construction of a railway commencing at Bristol 'in a certain field called Temple Mead' and terminating at Exeter. To pay for their scheme, the promoters were empowered to raise £1.5 million in shares, and a further £500,000 by loans. With Isambard Kingdom Brunel (1806–59) as its engineer, the B&ER was planned as an important broad gauge route, but relations with the neighbouring GWR were far from amicable, and in a letter

written to his cousin on 9 February 1836 George Gibbs (1785–1842), an important GWR supporter, was openly contemptuous; 'You may be quite assured,' he wrote, that the Bristol & Exeter Railway was

One of the greatest humbugs that ever was concocted. I believe now that the only reason why it is not seriously opposed here is the prevailing opinion that it is too absurd a measure to be carried into effect ... Unless it is opposed I have no doubt it will be pushed forward, unless indeed the wise people of the west should open their eyes to the danger of trusting their purposes to the levelling Quakers and other radicals who have the management of the Joint Stock Bank!

Happily, other Great Western supporters adopted a more sympathetic attitude towards the Bristol & Exeter project, and in 1840 it was agreed that, when completed, the Exeter line would be worked by the GWR. Construction of this new main line presented few problems, and the railway was opened as far as Bridgwater on Tuesday 1 July 1841, the inaugural special again being hauled by the 'Firefly' class locomotive *Fireball*. Regular public services commenced between Bristol and Bridgwater on 14 June 1841, on which day a 1½-mile branch line from Weston Junction to Weston was also brought into use.

The B&ER line was extended from Bridgwater to Taunton on 1 July 1842, while on 1 May 1843 a further extension allowed trains to reach a temporary station at Beambridge, near Wellington. Subsequent progress was halted for a while by the need to tunnel through the intervening Blackdown Hills, but finally, on 1 May 1844, the Bristol

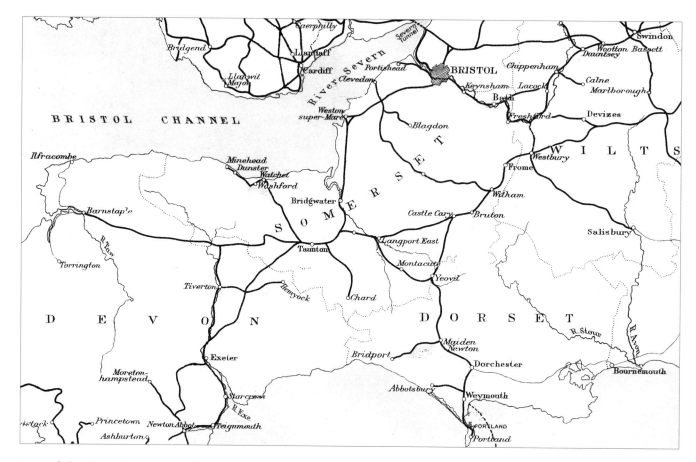

Map of the Bristol to Exeter Line

A map of the Great Western system in Devon, Somerset and Dorset, showing the route of the Bristol & Exeter main line between Bristol, Taunton and Exeter. The important branch lines to Minehead and Barnstaple diverge north-westwards and westwards respectively, while the Berks & Hants route, which provides a shortened path for West of England services travelling to or from Paddington, converges with the B&ER line near Taunton.

& Exeter Railway was completed throughout to Exeter – the occasion being celebrated in appropriate fashion by the running of a directors' special from Paddington, followed by a banquet in the goods shed at Exeter station.

The Bristol & Exeter system was initially worked by the GWR, but latent hostility between the two companies intensified when it became known that the Great Western was planning a more direct route to Exeter that would obviate the lengthy detour through Bristol. This inevitably alienated the largely Bristol-based supporters of the B&ER, and on 1 May 1849 the company began to work its own train services as an independent concern – a situation which was destined to last for the next twenty-seven years.

EXPANSION OF THE SYSTEM

The Weston-super-Mare branch, which was built under powers obtained on 11 June 1838, left the main line about 18½ miles from Bristol, and terminated near the seafront. Passengers were conveyed between Weston and Weston Junction in railway vehicles hauled by horses, but in 1848 a self-propelled steam carriage, known as *Fairfield*, was placed into service. However, this early railcar was not entirely satisfactory, and the vehicle was withdrawn in 1856. In the meantime, conventional steam power had been introduced on the Weston-super-Mare line.

Short branch lines were brought into use from Tiverton Junction to Tiverton on 12 June 1848, and from Yatton to Clevedon on 28 July 1847, while further branch lines were subsequently opened to serve Yeovil (1 October 1853), Chard (11 September 1866), Cheddar (3 August 1869), Barnstaple (1 November 1873), Minehead (16 July 1874), Hemyock (29 May 1876) and Blagdon (4 December 1901).

The Weston-super-Mare branch was adapted for mixed gauge operation in 1875, while the station facilities at Weston were considerably improved – a new terminus with a separate 'excursion' section being brought into use, together with an 'excursion hall' in which trippers could obtain refreshments. On 19 July 1875, powers were obtained for a 4-mile loop line, which would leave the main line at Worle Junction and rejoin it at Upwey Junction – the idea being that an entirely new station would be constructed at Weston-super-Mare to permit through running between Bristol and Exeter. The new station and loop line were opened on 1 March 1884. Weston Junction station and the earlier branch line were closed, while the old terminus became part of an enlarged goods depot.

The Weston Loop was standard gauge from its inception, though the Bristol & Exeter main line continued to carry long-distance broad gauge trains until the abolition of the 7-foot gauge in May 1892. In the interim, the period of estrangement between the GWR and B&ER companies had come to an end, and the Bristol & Exeter company was leased to the Great Western from 1 January 1876. Complete amalgamation followed just seven months later, on 1 August 1876.

The completion of the Castle Cary to Taunton cut-off scheme in July 1906 resulted in the diversion of most Paddington to Penzance services onto the shorter route via Reading and Westbury, but the loss of traffic between Taunton and Bristol was mitigated, to some extent, by a growth in long-distance cross-country traffic between populous industrial cities such as Birmingham and Wolverhampton and the West Country.

THE SOUTH DEVON RAILWAY

The successful opening of the Bristol & Exeter Railway was a source of obvious encouragement for those seeking to extend the broad gauge system further westwards, and within the next few months work had started on the aptly named South Devon Railway (SDR) between Exeter, Teignmouth, Newton Abbot and Plymouth. Another company

had been formed to construct the Cornwall Railway as a continuation of the SDR route while, further west, the West Cornwall Railway was being planned as a link between Truro and Penzance. In due course, these diverse undertakings would become integral parts of the West of England main line, carrying GWR trains between London, Bristol, Plymouth and Penzance.

The South Devon Railway prospectus, issued in October 1843, stated that the proposed line from Exeter to Plymouth would be a little over 51 miles in length, while the estimated cost of construction would be £1.1 million. The South Devon scheme was supported by the Great Western, Bristol & Exeter and Bristol & Gloucester railways which, between them, had supplied much of the capital needed for this broad gauge main line. After an easy passage through Parliament, the necessary Act of Incorporation was obtained on 4 July 1844.

The authorised route commenced at Exeter and ran south-eastwards along the estuary of the River Exe for about 11 miles to Dawlish Warren, where it reached the sea. Turning south-westwards, the proposed line then followed the seashore for about 6 miles to Teignmouth, at which point the Teign Estuary provided a convenient path inland towards Newton Abbot. Beyond, the SDR route struck inland on its way to Plymouth, the total distance from Exeter to Plymouth being 52 miles.

The South Devon Railway was, from its inception, a close ally of the GWR, the Great Western link being underlined by the appointment of I. K. Brunel as SDR engineer. In the early months of 1845, Brunel reported that tunnelling operations on the coastal section at Dawlish had 'proceeded most satisfactorily'. The principal tunnel was nearly complete, and 'the greater part of the blasting' had been carried out.

The line was opened as far as Teignmouth on 30 May 1846, and the SDR was extended to Newton Abbot on Thursday 31 December – Opening day 'being ushered in by the firing of salutes from the heights

... and by the ringing of merry peals on the parish bells as early as five o'clock'. At ten o'clock a procession was formed by local dignitaries, who proceeded to the station to greet the 'First Train'. The procession then returned to the town centre, led by the Totnes Band, with the Teignmouth Band bringing up the rear. Banners proclaimed 'SUCCESS TO THE SOUTH DEVON RAILWAY', 'BRUNEL & THE BROAD GAUGE', and other appropriate mottos, while on arrival at the Globe Hotel the procession was welcomed by load cheering.

The line was extended to Totnes on 20 July 1847, while on 5 May 1848 the railway reached Laira Green, a little short of its ultimate destination at Plymouth. Finally, on 2 April 1849, the South Devon Railway was completed throughout to Plymouth (Millbay), and a continuous line of communication was established between Plymouth, Exeter, Bristol, Reading and London.

The South Devon line was notable in that, for a few months in 1848, the section from Exeter to Newton Abbot was worked on the 'atmospheric' system, whereby trains were propelled by compressed air. Although this novel and innovative system had, apparently, functioned with relative success on the Dublin & Kingstown Railway, the South Devon company was unable to continue with this method of propulsion. Atmospheric working was abandoned in the summer of 1848, and the SDR was then worked entirely by steam locomotives. The South Devon Railway was leased to the Great Western from 1 February 1876 and, on 1 August 1878, the SDR was fully and finally amalgamated with the GWR.

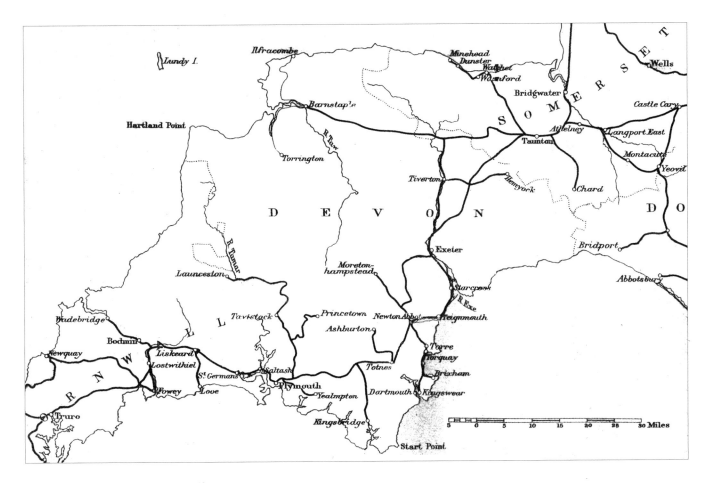

Map of the South Devon Railway
A map of the Great Western system in Devon and Cornwall, showing the route of the South Devon main line between Exeter, Teignmouth, Newton Abbot and Plymouth.

TEMPLE MEADS STATION

As mentioned earlier, Bristol Temple Meads was opened for public traffic on 31 August 1840, when the westernmost section of the Great Western main line was brought into use between Bristol and Bath. The original GWR terminus, with its magnificent hammerbeam roof, was aligned from east-to-west, but when the Bristol & Exeter Railway was opened in 1841 the B&ER terminus was laid-out on a north–south axis – the two stations being awkwardly-situated at right angles to each other. A sharply-curved connecting line permitted through running between the two systems, but this situation was far from ideal, and in 1865 the GWR, B&ER and Midland companies obtained Parliamentary consent for a new 'joint station'. When finally completed in 1878 the enlarged station consisted of the original Brunelian terminus, together with new through platforms that diverged south-westwards on a curving alignment. The new through platforms were covered by a Gothic-style train shed, while the roughly triangular space between the 1840s and 1870s stations was filled by a range of substantial stone buildings, all of which exhibited late Medieval features.

There were originally just two platforms beneath the 1878 train shed. Following the abolition of the broad gauge in 1892, two very narrow island platforms were squeezed into the gap between the two earlier platforms, while space was also found for an additional bay platform on the down side. The platforms were linked by a footbridge, which was totally inadequate on summer Saturdays, when Temple Meads became a notorious bottleneck on the West of England main line.

The problems at Temple Meads were finally resolved in the 1930s, when the station was improved and expanded, and two curved island platforms were added on the east side. The enlarged facilities were so extensive that the rebuilt station covered more than three times its former area. The island platforms beneath the through train-shed were removed and in their place two through lines were installed, these being known as the up middle and up loop lines.

The original station buildings were retained, although the eastern wall of the 1878 train-shed was pierced by a series of large Tudor arches to provide convenient access between the platforms. This transformed the gloomy interior of the train shed into a more attractive place, with plenty of natural light. Interior alterations undertaken included a rearrangement of the booking hall and the provision of a large cloakroom that was accessible from the station approach road and from Platform 10. The new through platforms were equipped with waiting rooms, refreshment rooms, offices and staff mess rooms, while the new platforms were covered by canopies for much of their length.

The GWR publicity department was particularly pleased with the new refreshment rooms, which were fitted-out on a palatial scale. The fine new room provided to serve Platforms 3, 4 and 5 was regarded as unique. Its walls were lined to dado height with Napoleon and Botticino marble, the panelling above the dado being of Indian silver-grey wood with quartered veneer panels. The skirting was of black marble, while the pale yellow semi-gloss ceiling was calculated to be cool in summer and comfortable in winter. This building was of two stories, the upper floor being furnished as sleeping accommodation for refreshment room staff. A separate refreshment room was opened on Platform 6, while the former dining and refreshment rooms on the main up platform were considerably enlarged and improved.

The platforms were linked by a spacious subway, which was 300 feet long and 30 feet wide. There were broad stairways for passengers as well as electric lifts for the movement of luggage, while a branch subway gave convenient access to the station from Cattle Market Street.

Bristol Temple Meads – The Main Station Building

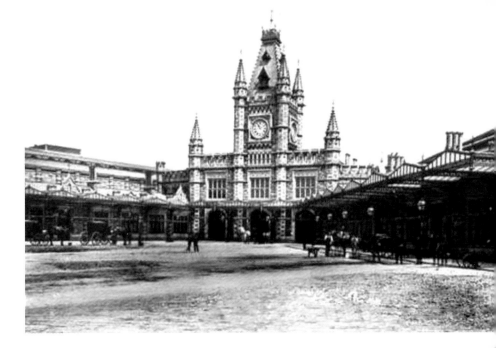

An Edwardian postcard view showing the main station building at Temple Meads, which boasts an impressive tower with four tall pinnacles, together with two flanking pinnacles and a crenellated parapet. Until 1941, the central tower had been graced by a stubby spire, as shown in the picture, but this feature was destroyed by enemy action during the Second World War. The original GWR terminus is to the left of the picture, while the 1870s train shed can be seen to the right.

Bristol Temple Meads – The Interior of the 1870s Train Shed

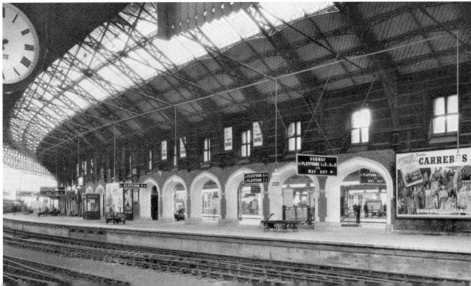

This 1935 view of up Platform 7 shows the Tudor-Gothic arches that were inserted into the wall of the 1870s train shed as part of the 1930s reconstruction scheme. In steam days, the platforms were numbered in logical sequence, although this may not have been entirely clear to ordinary travellers, as the longest platforms were treated as 'double' platforms and numbered accordingly. The island platform on the eastern side of the station formed platforms 1 and 2, while the neighbouring island comprised 3, 4 and 5; one of its two faces was regarded as a double-length platform. Down Platform 5 was flanked by up Platform 6, but platforms 7 and 8, beneath the 1870s overall roof, were the two halves of a very long through platform. Moving westwards, platforms 9 and 10 were the two parts of another very long island platform with an overall length of 1,366 feet, while Platform 11 was a short bay on the up side. Finally, platforms 12, 13, 14 and 15 were two double-length platforms serving the original Brunel terminus on the north side of the station.

Bristol Temple Meads – The East Signal Box

As a result of a major resignalling scheme carried out by the GWR in 1934/35, Bristol Temple Meads station was signalled from three power signal boxes. Bristol Temple Meads East Box, at the London end of the station, had 368 levers, while Temple Meads West Box, at the opposite end of the station, had 328 levers. In addition, there were 39 push-buttons at Temple Meads West Box and 18 at Temple Meads East Box; these were used in conjunction with the main running line signal levers for working calling-on signals. A third box, known as Temple Meads Yard, had 32 levers. When first brought into use, the Bristol resignalling scheme was the largest power signalling scheme in the country, although the colour light searchlight signals employed in this scheme were only single-aspect signals, displaying the same red, green or amber indications that would have been displayed by conventional semaphore signals at night.

The Bristol area was resignalled for a second time as part of a twelve-stage multiple-aspect signalling programme that was put into effect between August 1969 and December 1971. A new panel box was brought into use at Temple Meads and, when the scheme was finally completed, this new facility controlled 114 route miles (253 track miles) and 142 points.

Bristol – Temple Meads Station

The platform numbering sequence was, in effect, reversed in 1970, the old Platform 12 becoming Platform 1, while the old platforms 9 and 10 became the present platforms 3 and 4. The lengthy through platforms in the centre part of the station were still regarded as double-length platforms, platforms 7 and 8 having become platforms 5 and 6, while Platform 6 is now platforms 7 and 8. The former Platform 1, on the eastern side of the station, was taken out of use in 1970, but it has latterly been reinstated as Platform 15. The photograph shows a 'Peak' class locomotive alongside the present Platform 10 (formerly Platform 5) in February 1971. The former Bristol & Exeter Railway station building can be glimpsed in the background.

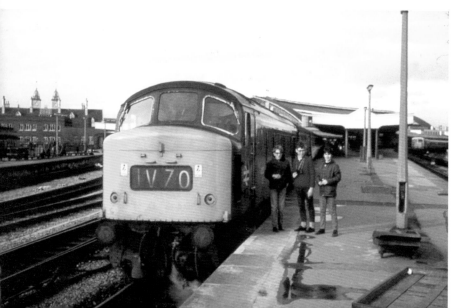

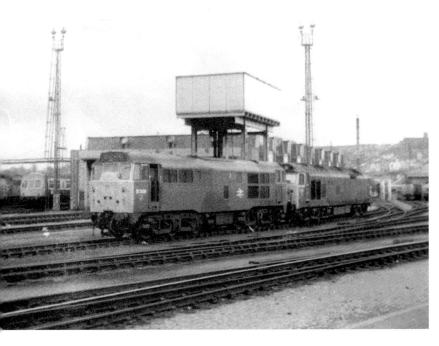

Right: Bristol Temple Meads

A small tethered balloon hangs incongruously above Bristol Temple Meads station as class '50' locomotive No. 50050 *Fearless* departs with the NENTA Traintours Felixstowe to Minehead 'Star Coast to Coast Explorer' railtour on 17 July 1999. The Mk 2 coaches are in Anglia Railways livery. Unfortunately, *Fearless* failed with a defective gasket on the return journey. The 1870s train shed features prominently in the background, while the former Bristol & Exeter station building can again be seen on the left of the picture.

Left: Bristol Temple Meads – Bath Road Locomotive Shed

Bath Road shed was sited immediately to the east of the passenger station, its facilities being clearly visible from the neighbouring platforms. The shed was opened in 1934 as part of the Bristol reconstruction scheme, this ambitious programme of new works having been financed under the provisions of the Loans & Guarantees Act of 1929, which enabled the railway companies to obtain cheap government loans for the major infrastructure projects that would help to alleviate the effects of mass unemployment.

Bath Road was later rebuilt as a diesel depot, and the photograph shows class '31' No. 31308 and class '50' No. 50002 *Superb* outside the modernised shed during the 1980s. Sadly, the depot was closed following privatisation in the 1990s, the site being too large for any of the privatised train operating companies to take it over.

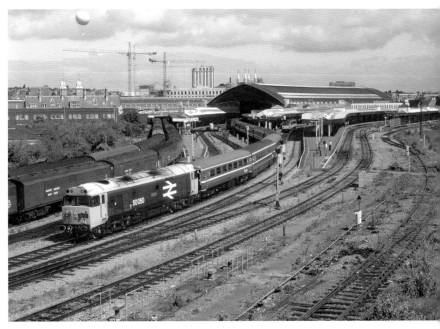

Right: Bristol – Malago Vale
Continuing westwards through a built-up urban area, down trains pass the site of Malago Vale Carriage Sidings (119 miles 50 chains), which have now been replaced by a modern housing development. The colour photograph shows an HST set headed by power car No. 43029 passing the weed-choked and derelict sidings while working the 10.25 a.m. Liverpool Lime Street to Plymouth service on 5 April 1990.

Left: Bristol – Bedminster & Malago Vale
On leaving Bristol Temple Meads, trains run first south and then westwards through an urban landscape to the first intermediate station at Bedminster, which is 119 miles 22 chains from Paddington. Opened as Ashton in June 1871, this suburban station was rebuilt on a new site in May 1884. It was extensively reconstructed in connection with the quadrupling of the line in the early 1930s. Prior to rationalisation, the station had four platform faces, as shown in the upper picture, although only three now remain. The up and down sides of the station are linked by an underline subway, while the platforms are now equipped with modern waiting shelters.

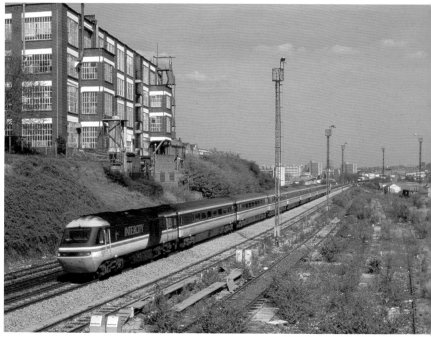

Bristol – Passing Malago Vale

Right: 'King' Class 4-6-0 No. 6024 *King Edward I* makes a vigorous departure from Bristol as it passes Malago Vale with the Pathfinder Tours Coventry to Par 'Par King Pioneer' railtour on 9 May 1998. The 'Kings' were banned from Devon and Cornwall in steam days, but track improvements carried out in recent years have enabled these 135-ton locomotives to run throughout to Cornwall on the West of England main line. *Bottom left*: Class '37' locomotive No. 37667 *Meldon Quarry Centenary* hauls a featherweight load of three 'OTA' timber wagons as it approaches Bristol while working the 4.56 a.m. St Blazey to Newport Alexandra Dock Junction Enterprise service on 9 May 1998. The train is heading eastwards past the site of Malago Vale sidings, and Parson Street station can be seen in the distance. *Bottom right*: Class '50' locomotive No. 50015 *Valiant* scuttles past the overgrown sidings with the 8.27 a.m. Bristol East to Exeter Riverside departmental working on 21 September 1990.

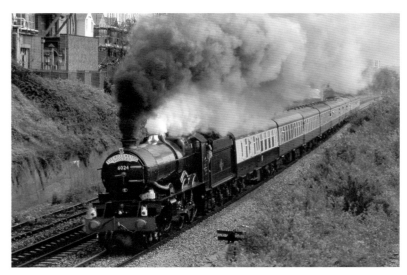

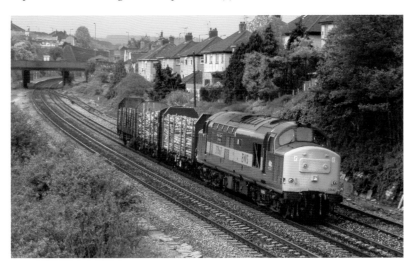

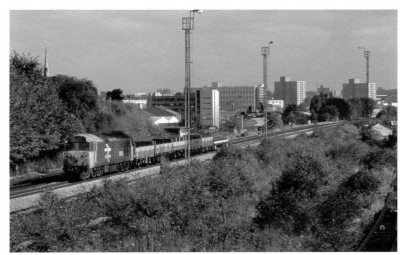

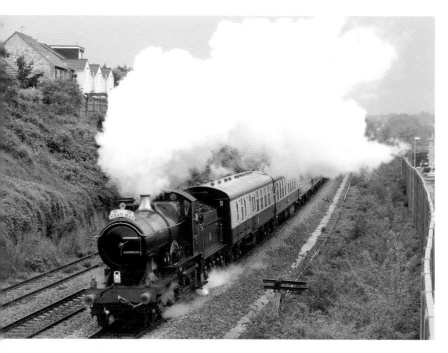

Left: Bristol – *City of Truro* at Malago Vale

The double-framed 'City' class 4-4-0s were introduced in 1903 as an improved version of the slightly earlier 'Atbara' class. On 9 May 1904, 'City' class 4-4-0 No. 3440 *City of Truro* achieved lasting fame when it reached a record speed of 102.4 mph as it descended Wellington Bank, to the west of Taunton, while working a Plymouth to Paddington Ocean Mail train. This historic feat was marked on 8 May 2004 when No. 3440 commemorated its record-breaking run by retracing the same route, almost exactly 100 years after the event. The famous locomotive is pictured here passing Malago Vale, soon after leaving Bristol Temple Meads with the 9.55 a.m. Bristol Temple Meads to Kingswear 'Ocean Mail 100' railtour.

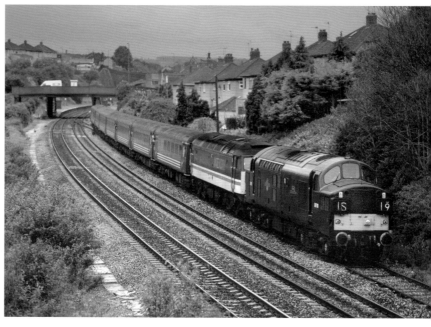

Right: Bristol – Parson Street

Class '37' locomotive No. D6700 *NRM National Railway Museum* was called upon to perform an unusual working on Saturday 12 June 1999. The driver of the 11.30 a.m. (Friday) Manchester Piccadilly to Paignton Virgin Cross Country service was not certified to drive class '47s', and No. D6700 was therefore pressed into service as a pilot locomotive between Bristol and Paignton. As a consequence, the 8.58 a.m. return working from Paignton to Glasgow was also worked by the veteran class '37' locomotive as far as Bristol Temple Meads. The northbound train is shown here emerging from the Parson Street cutting and approaching the site of Malago Vale carriage sidings, just a short distance from the end of its historic run, with class '47' locomotive No. 47851 coupled behind No. D6700.

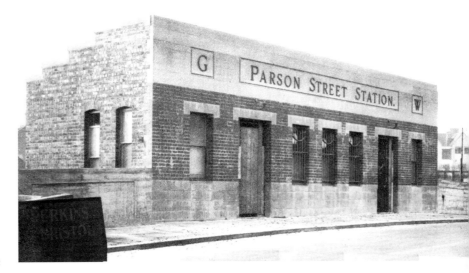

Bristol – Parson Street & Long Ashton

Above: Parson Street station (120 miles 15 chains), which is situated in a cutting just beyond Malago Vale carriage sidings and can be seen in some of the preceding photographs, was opened on 29 August 1927. The station was reconstructed when the line was quadrupled during the early 1930s, two island platforms being provided, each with a length of over 600 feet, while a new, brick-built station building was erected on the Parson Street Road bridge at the east end of the station.

Below: Class '31' locomotive No. 31276 *Calder Hall Power Station* and unnamed sister locomotive No. 31217 pass Parson Street with the 2.00 p.m. Bridgwater to Sellafield nuclear flask train on 5 April 1990.

Long Ashton Platform, the next stopping place (122 miles 3 chains), was little more than a staffed halt, with two 400-foot platforms. It was opened on 12 July 1926 and closed in October 1941, although it has been suggested that a new station might be opened as part of the University of Bristol's Fenswood Park development scheme.

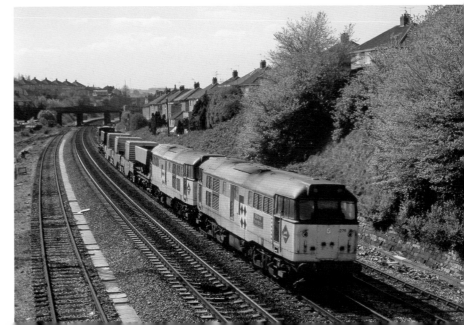

Right: Flax Bourton

Class '47' locomotive No. 47826 speeds past the site of Flax Bourton station with the 8.20 a.m. Edinburgh to Penzance 'Cornish Scot' service on 5 April 1990. A complete rake of InterCity liveried stock with matching locomotive was a surprisingly rare occurrence at the time, but unfortunately the uniform colour scheme is slightly spoilt by the shabby condition of the engine.

Left: Flax Bourton

Heading westwards into open countryside, trains pass through the 110-yard Flax Bourton Tunnel before reaching the site of Flax Bourton station (124 miles 21 chains). This wayside station was opened as Bourton on 1 September 1860, and rebuilt on a new site a quarter mile further to the west on 2 March 1893. Up and down platforms were provided here; the main station building, of standard Great Western design, was on the up side, while a somewhat smaller waiting room was available on the down platform. Both of these buildings were of red-brick construction, with hipped roofs and projecting platform canopies. The modest goods yard, which could deal with coal, furniture, livestock, vehicles and general merchandise traffic, was sited to the west of the platforms on the up side. Sadly, passenger services were withdrawn from this station on Monday 2 December 1963, although goods traffic was handled until July 1964. The photograph is looking eastwards around 1912.

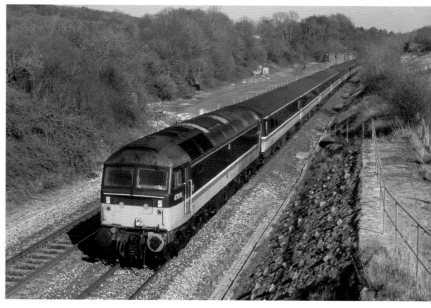

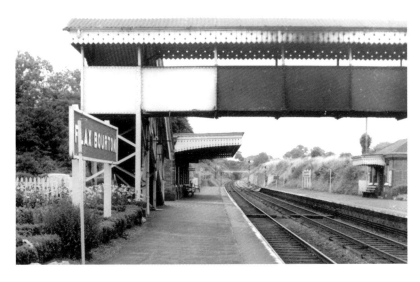

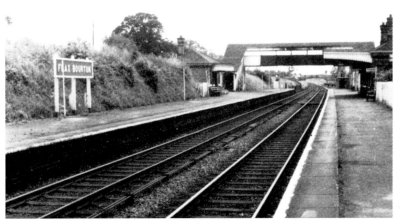

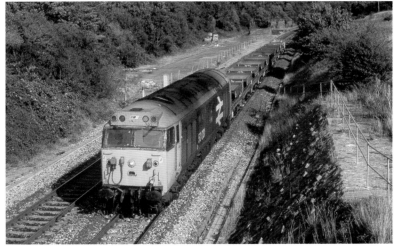

Flax Bourton

Above left & above right: Two further views of Flax Bourton station, both of which are looking east towards Bristol during the early 1960s. *Below*: Class '50' locomotive No. 50031 *Hood* passes Flax Bourton with the 2.37 p.m. Bristol East to Exeter Riverside departmental working on 21 September 1990. The derelict station buildings can be discerned in the distance.

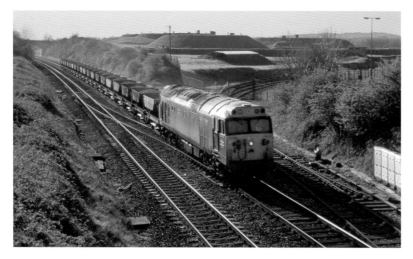

Flax Bourton

Left: Glinting in the strong backlighting, class '50' locomotive No. 50019 *Ramillies* passes the rail-served Tyntesfield oil depot at Flax Bourton while hauling a Meldon Quarry to Bristol East ballast working on 5 April 1990; Tyntesfield siding, on the up side of the line, was originally laid to serve a Ministry of Fuel storage depot. *Below left*: Class '31' locomotive No. 31454 *Heart of Wessex* passes Flax Bourton with the 2.06 p.m. Bristol Temple Meads to Minehead 'Butlins Express' on 11 August 2007. *Below right*: Class '143' unit No. 143618 passes Flax Bourton with the 2.02 p.m. Bristol Parkway to Weston-super-Mare First Great Western service on 11 August 2007.

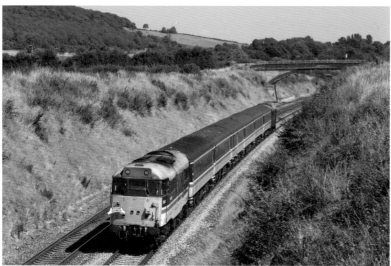

Flax Bourton

Right: HST power car No. 43107 *Tayside* leads the 10.32 a.m. Virgin Cross Country Paignton to Newcastle Central service past Flax Bourton on 11 August 2007. Due to the inadequacy of the Voyager fleet, this Great North Eastern Railway set had been hired from GNER to work Saturday services to the West of England during the summer peak. *Below left*: Class '158' unit No. 15855 *Exmoor Explorer* passes Flax Bourton while working the 11.37 a.m. Weston-super-Mare to Bristol Temple Meads First Great Western service on 11 August 2007. *Below right*: Class '31' locomotive No. 31452 *Minotaur* approaches Flax Bourton with the 11.10 a.m. Minehead to Bristol Temple Meads 'Butlins Express' on 11 August 2007, with classmate No. 31454 assisting at the rear.

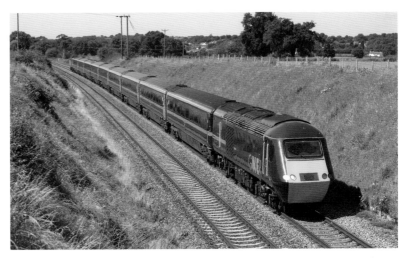

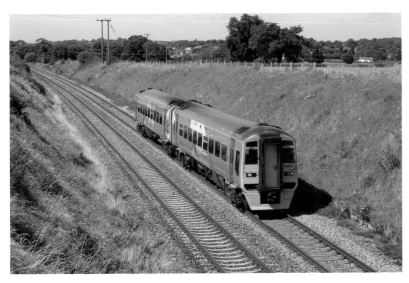

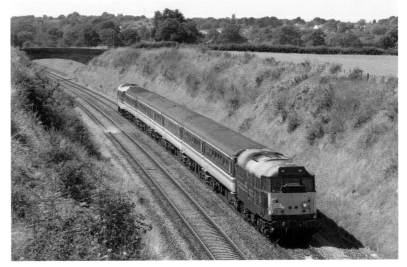

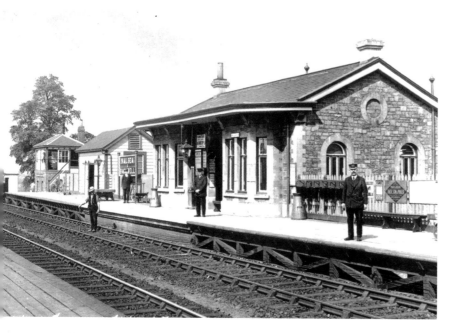

Right: **Nailsea & Blackwell**

A general view of the station during the early 1960s, looking north-eastwards along the up platform, with the standard GWR plate girder footbridge visible in the background. The station remains in operation, but its Victorian station buildings have been replaced by simple waiting shelters.

Left: **Nailsea & Blackwell**

Nailsea & Blackwell, the next station (126 miles 34 chains), was opened by the Bristol & Exeter Railway on 14 June 1841. The station is situated on an embankment, and the main station building, on the up platform, was a split-level structure with its entrance at ground level. The building was mainly built of local stone, with a low-pitched gable roof, as shown in the accompanying photographs. The up and down platforms were connected by a plate girder footbridge, while the goods yard was sited to the west of the platforms on the up side. The 1938 Railway Clearing House *Handbook of Stations* reveals that the yard was able to deal with coal class traffic and general merchandise.

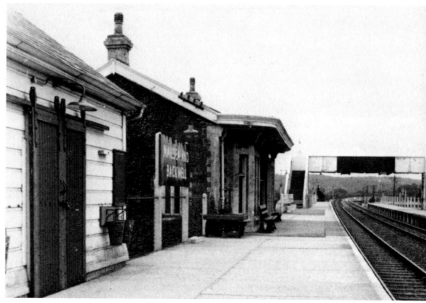

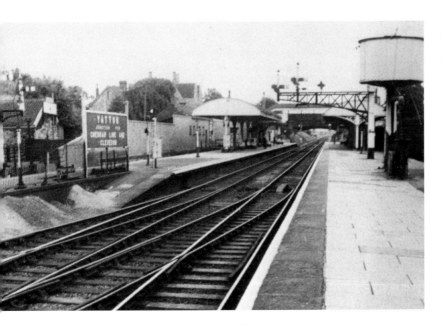

Left: Yatton

Heading south-westwards along the more or less dead flat Bristol–Exeter route, trains soon reach Yatton (130 miles 28 chains), which was formerly the junction for branch services to Clevedon and Cheddar. This extant station was opened as Clevedon Road on 14 June 1841, while the Clevedon and Cheddar branches were opened on 28 July 1847 and 3 August 1869 respectively. Yatton was a well laid out station, with up and down platforms for main line traffic and terminal platforms for branch line services; the Clevedon bay was on the up side, while the Cheddar bay was on the opposite side of the station. The main station building was on the up platform, and there was an accretion of smaller buildings on the down side. The main building, a Brunelian chalet-type structure with a low-pitched, hipped roof, contained the usual booking office and waiting rooms. The up and down sides of the station were linked by a typical GWR covered footbridge. The photograph is looking north-east towards Bristol and Paddington.

Right: Yatton

A general view of the station, looking north-east towards Bristol during the early 1960s. The Clevedon branch bay can be seen to the left, while the Cheddar platform is on the right-hand side of the picture. The Clevedon bay had no run-round loop, although this posed no real problem insofar as the Clevedon line was normally worked by push-pull 'auto-trains'. However, when non-auto-fitted locomotives were employed, incoming trains had to reverse onto the Clevedon line so that running-round could take place on a short section of double track. Cheddar Valley trains normally ran through to Witham; the summer 1910 timetable, for example, provided four trains each way between Yatton and Witham, together with three up and two down workings between Yatton and Wells, and two trains each way between Wells and Witham. The Cheddar route was famous for its strawberry and limestone traffic – indeed, stone traffic is still handled at the southern end of the route.

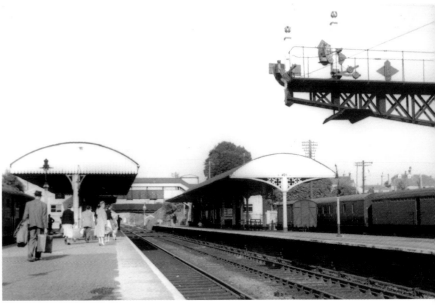

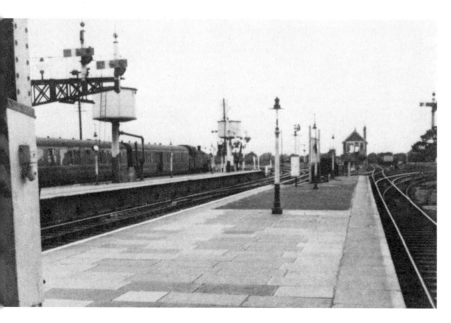

Left: Yatton

A *c.* 1963 view of Yatton station, looking south-west along the up platform. A Cheddar branch train is standing in the down bay, while the Clevedon branch platform can be seen to the right. Yatton boasted a comparatively complex track plan, with loops and sidings on both sides of the running lines. There was a goods yard, containing a goods shed and loading docks, behind the platforms on the down side; one of the sidings was known as 'The Strawberry Bay'. A single-road engine shed was sited beside the Clevedon branch on the up side of the station, and this normally housed two or three 2-6-2T or 0-4-2T locomotives. The station was signalled from two signal boxes known as Yatton East and Yatton West boxes. Yatton West Signal Box, which can be seen in the photograph, was a large hip-roofed structure, of typical Bristol & Exeter design, which contained over 100 levers.

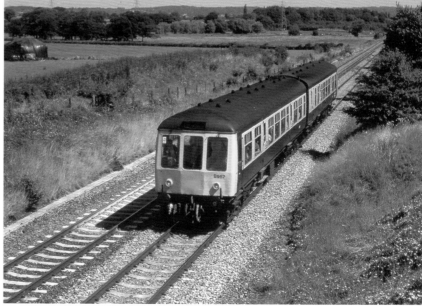

Right: Yatton

Class '108' unit No. B967 passes Claverham as it approaches Yatton with the 12.17 p.m. Bristol Temple Meads to Weston-super-Mare local service on 10 August 1989. This unit, which was formed of driving trailer composite No. 54230 and motor brake second No. 53619, was to see mixed fortunes in the following years: No. 54230 was withdrawn in November 1992 and cut up almost immediately at Booths at Rotherham, but No. 53619 is now running on the Dean Forest Railway (as No. 50619). The class '108' units were introduced in 1958, over 330 vehicles being constructed at Derby Works. They remained in use on the national system until the early 1990s, and many examples are now in use on heritage railways such as the Severn Valley Railway and the Dean Forest line.

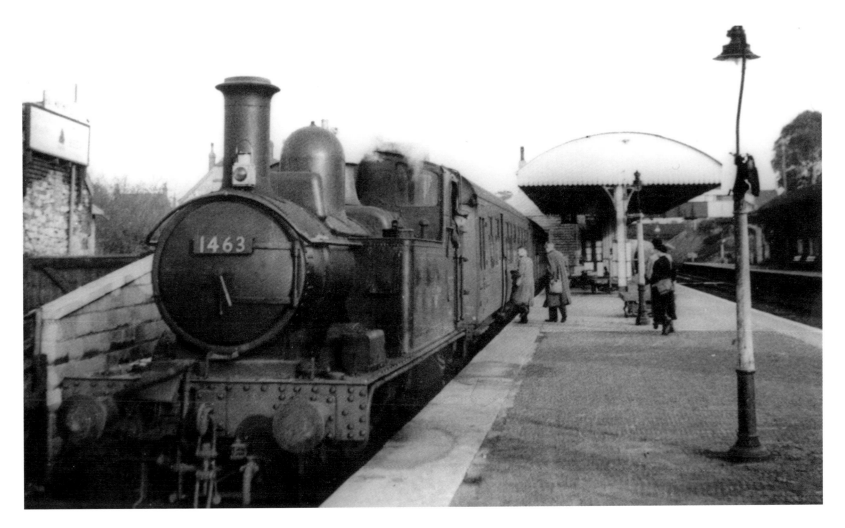

Yatton

A detailed study of the Clevedon branch train as it waits in the up bay platform during the early 1960s. The locomotive is Collett '14XX' class 0-4-2T No. 1463, which was built at Swindon in 1936 and withdrawn from service in 1961. The arc-roofed canopy that can be seen beyond the train was erected during the 1950s in place of an earlier train shed, the 'new' canopy having been moved from a redundant branch platform at Dauntsey, on the Berks & Hants line.

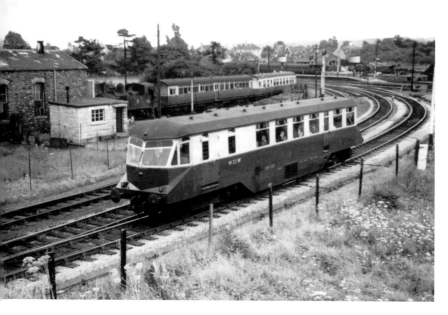

Left: Yatton

Former Great Western diesel railcar No. W25W leaves Yatton with a Clevedon branch working during the early British Railways period. Yatton's single-road engine shed can be seen in the background. This stone-built structure measured approximately 80 feet by 20 feet at ground level; in BR days it was a sub-shed of Bristol Bath Road. The allocation in January 1921 comprised 'Metro' 2-4-0T No. 630 and '517' class 0-4-2T No. 1428, together with steam railmotor car No. 95, while in January 1948 the resident locomotives were '45XX' class 2-6-2T No. 4563 and '14XX' class 0-4-2T Nos 1415 and 1463.

Right: Yatton

Class '143' unit No. 43617 calls at Yatton station with the 9.37 a.m. Taunton to Bristol Temple Meads service on 30 June 2001. A surprising amount of Victorian infrastructure has survived here, although Yatton is no longer a junction station. The Cheddar branch was closed from Monday 9 September 1963 and, as there was no Sunday service, the last trains ran between Yatton and Witham on Saturday 7 September 1963. As usual on such occasions, many people turned out to see and photograph these final workings; one of the locomotives employed on the last day was ex-LMS Ivatt class 3MT 2-6-2T No. 41245, which worked the 1.45 p.m. afternoon service from Yatton. The final train from Yatton to Witham at 6.15 p.m. was headed by '2251' class 0-6-0 No. 2268. The Clevedon branch was closed to passengers from 3 October 1966, the last trains being run on Saturday 1 October.

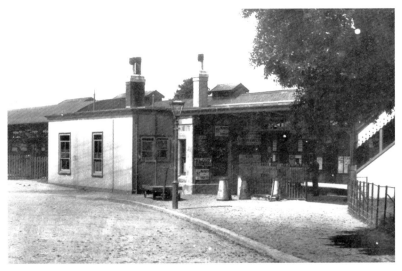

Yatton

Right: A detailed view showing part of the down side station buildings, possibly during the 1920s. *Below left*: British Railways Standard class '9F' 2-10-0 No. 92233 enters Yatton station with a westbound express passenger working during the early 1960s. *Below right*: A final view of Yatton station, looking north-eastwards along the down platform during the early 1960s. Although Yatton no longer serves as the junction for Clevedon and Cheddar Valley branch services, this Somerset station remains relatively busy, and in recent years it has generated around 384,000 passenger journeys per annum.

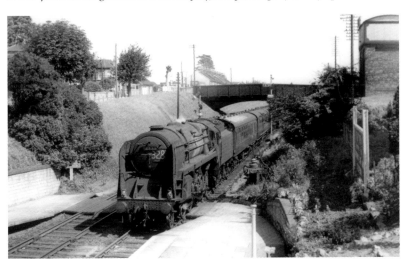

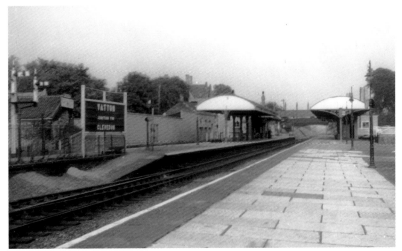

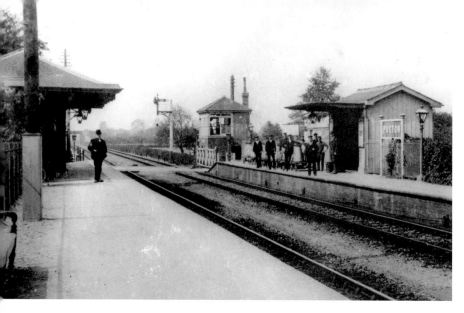

Puxton & Worle

Continuing south-westwards, down trains pass the site of a small station known as Puxton & Worle (133 miles 75 chains), which was opened on 14 June 1841 and closed on 6 April 1964. The station served a number of scattered villages, including Bourton, St Georges and Worle on the north side of the line, and Puxton, Rolstone and Banwell to the south. When first opened, this wayside stopping place had been known as Banwell, but the names Worle and Puxton were both used before the GWR finally adopted the composite appellation Puxton & Worle.

 The track layout incorporated two goods sidings on the down side, and an additional siding for dairy traffic on the opposite side of the line. The goods yard contained a goods shed, coal wharves, a cattle loading dock and a 6-ton yard crane, while a level crossing was sited immediately to the west of the platforms. Architecturally, Puxton & Worle, interesting as its main station building, on the down side, was a Brunelian hip-roofed design that, from its appearance, dated back to the earliest days of the Bristol & Exeter Railway. The up side buildings, in contrast, comprised two open-fronted wooden shelters, the largest of which was a Great Western addition.

Puxton & Worle

Class '155' unit No. 155325 passes the site of Puxton & Worle station while working the 1.38 p.m. Bristol Temple Meads to Taunton Regional Railways service on 25 April 1990. Much building work is evident here, and further development has taken place on both sides of the line since this picture was taken.

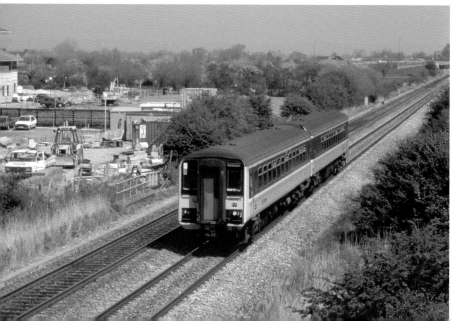

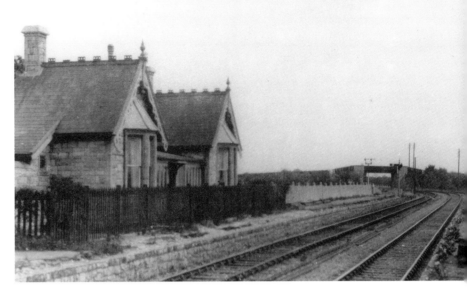

Puxton & Worle

Although the original Puxton & Worle station was closed to passengers in 1964, a new stopping place known as Worle was opened by the chairman of Avon County Council on 24 September 1990. Situated on a fresh site to the south-west of the original stopping place, the new station was funded jointly by BR and the county council, and it was brought into use for public traffic on 1 October 1990. Confusingly, the present station, which is 134 miles 42 chains from Paddington, is situated not far from the site of an earlier Worle station, which had been sited on the Weston-super-Mare loop line, a short distance to the west of Worle Junction. This first Worle station was opened on 1 March 1884 and closed in December 1921, but its substantial stone station building remained in situ for many years, as shown in these two photographs.

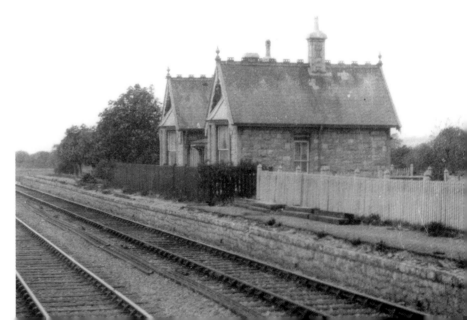

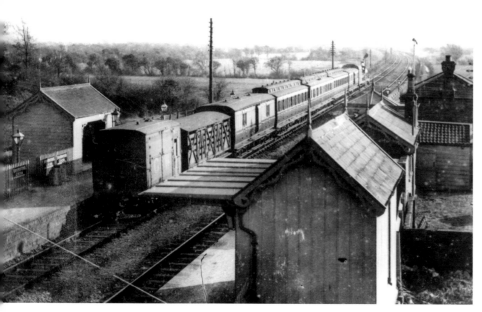

Bleadon & Uphill

With an endless vista of suburban housing developments now visible to the right, trains reach Worle Junction (135 miles 12 chains), before the Weston-super-Mare Loop diverges west-south-westwards from the B&ER main line. The latter route continues south-westwards, passing beneath the A371 road bridge and then skirting Weston-super-Mare Airport. Old Junction Farm and Old Junction Road mark the site of the long abandoned 1841 branch to Weston, which had diverged north-westwards from the B&ER main line. A small station known as Weston Junction (136 miles 60 chains) was provided at this point from 1841 until 1884. Continuing south-westwards along the Bristol & Exeter route, trains pass the Westland Aircraft factory, which was once served by a private siding on the down side of the running lines.

With houses, playing fields and industrial premises much in evidence, the line reaches Uphill Junction (138 miles 6 chains), where the Weston-super-Mare loop converges from the right, and having passed beneath another road overbridge, southbound workings pass the site of Bleadon & Uphill station (138 miles 49 chains). The facilities at this small stopping place comprised up and down platforms for passenger traffic, with a small, hip-roofed station building of typical Great Western design on the up platform and a Bristol & Exeter waiting shelter on the opposite side. There was no provision for goods traffic, although the station was able to deal with small parcels conveyed by passenger train. The upper view shows Bleadon & Uphill around 1906, while the lower view shows two unidentified 'Achilles' class 4-2-2 locomotives double-heading a down passenger train through the station during the final years of the Victorian period.

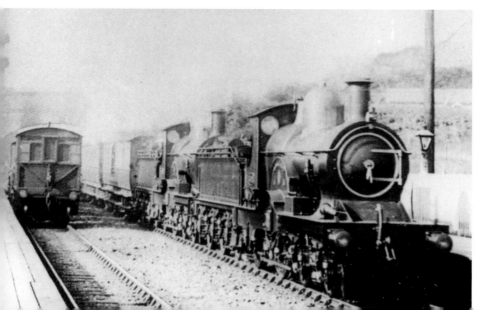

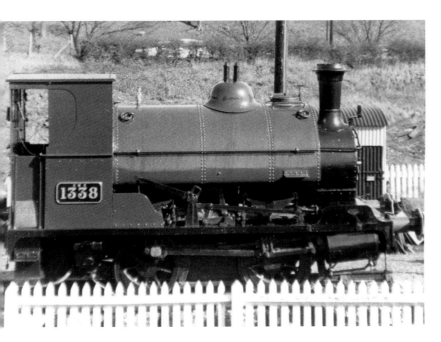

Right: Bleadon & Uphill

A collection of British Railways and GWR tickets from Bristol, Yatton and Weston-super-Mare, including a platform ticket from Bristol Temple Meads and a car parking ticket from Weston-super-Mare. Ordinary second- and third-class tickets were normally printed on green cards, while excursion tickets were usually creamy buff coloured. 'Privilege' tickets were reduced-fare tickets issued to railway employees and members of their families. Skeleton letters were printed on the left-hand side of Great Western return tickets for the purpose of readily distinguishing the description of traffic; ticket No. 3618, for example, bears the letter 'C' to denote 'Cheap Day Return'.

Left: Bleadon & Uphill – The Yieldingtree Railway Museum

Bleadon & Uphill station was closed on 5 October 1964, after which it was adapted for a new role as the Yieldingtree Railway Museum. This small private museum was owned by Robert Smallman, who had amassed a collection of signs, signalling equipment and other items from all parts of the British Isles. The station building housed most of the collection, while the signal cabin from Burnham-on-Sea was acquired for use as a shop. The main attraction was former Cardiff Railway 0-4-0ST No. 5, a Kitson shunter (works No. 3700) that had become GWR No. 1338 after the grouping. This diminutive locomotive was displayed as a static exhibit on a short length of track at the rear of the platform, together with an array of signals and other large items. The museum attracted about 5,000 visitors per annum (a fairly respectable figure), but in the event its life was very short, and the collection was auctioned in London on 8 February 1968.

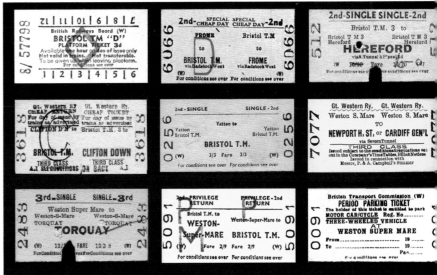

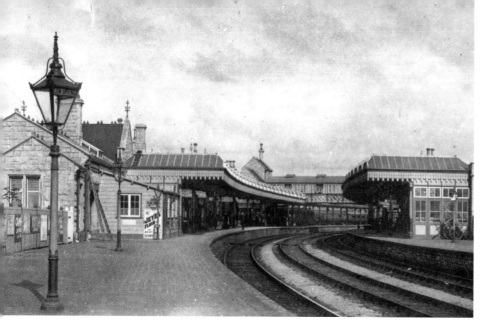

Weston-super-Mare

Having followed the route of the B&ER main line between Worle and Uphill junctions, we must now return to Worle Junction in order to examine the railway facilities at the holiday resort of Weston-super-Mare. After joining the Weston loop at Worle Junction, trains soon reach Weston Milton Halt (136 miles 9 chains), an unstaffed stopping place that had been brought into use in GWR days to serve new housing developments in the Milton area. With Locking Road following a parallel alignment on the right-hand side, the line continues west beneath a road overbridge, and into Weston-Super-Mare passenger station (136 miles 35 chains). The station was formerly known as Weston-super-Mare General, to distinguish it from the excursion station at Locking Road.

Weston-super-Mare – The Passenger Station

The present station was opened on 1 March 1884, when the Weston loop was brought into use. Weston Junction station and the earlier branch line were closed on that same date, while the old terminal station became part of an enlarged goods depot. The passenger station has seen few changes in recent years, its facilities being much the same as those in use during the heyday of steam operation. Two curved platforms are provided, with substantial, stone-built buildings on both sides. Prior to rationalisation, the layout had provided up and down running lines with a 'third road' or middle siding between them. There was, in addition, a terminal bay at the Paddington end of the up platforms, but this third platform was taken out of use in 1972. In steam days, water columns were sited at the north end of the up and the south end of the down platforms. It is interesting to note that when Sir Daniel Gooch (1816–89), the Great Western chairman, visited Weston-super-Mare on 20 September 1883, he noted in his diary that 'our new station is a fine building', suggesting that the new passenger accommodation had been completed several months before the Weston loop was brought into use.

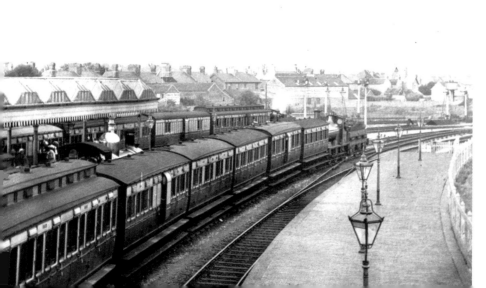

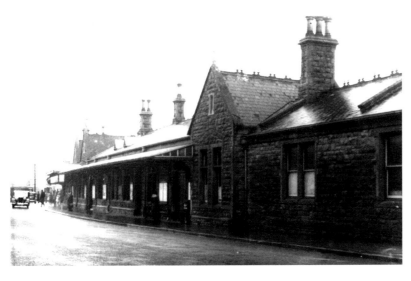

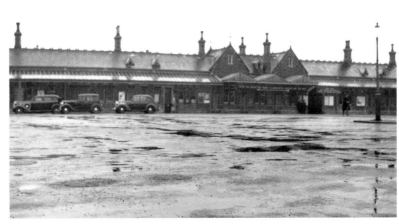

Weston-super-Mare – The Station Buildings

Above left & above right: Two photographs showing the main ticket office and waiting room accommodation on the up side on 10 July 1955. Architectural details reflect the Tudor-Gothic style, the mullion windows being square-headed, whereas the doorways have shallow, pointed arches. The stonework is laid in 'snecked' or interrupted courses, and the platforms are covered by extensive glazed canopies. *Right:* A detailed view of the fully enclosed footbridge.

The Weston loop remains in operation as part of the national rail system, and Weston-super-Mare station still handles large numbers of passengers, present-day train services being at least as good as those provided during the heyday of steam operation. In recent years, many London to Bristol services have run to and from Weston-super-Mare, giving the town a service of fast trains to Paddington. In September 1998, there were six up and five down workings between Weston and Paddington, a frequency comparable to that which had pertained during the last years of the GWR.

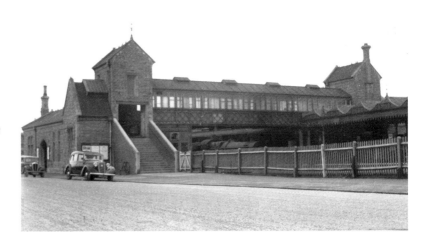

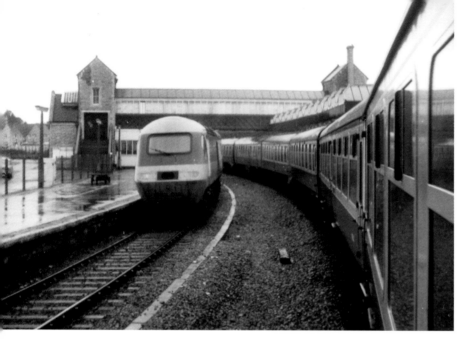

Weston-super-Mare – Signalling Details

A general view of the station, looking west towards Penzance around 1980. Weston-super-Mare was signalled from a number of mechanical signal boxes, including Weston-Super-Mare East and Weston-super-Mare West boxes, together with Worle Junction Box, Uphill Junction Box, Hutton Box, and the station boxes at Puxton & Worle and Bleadon & Uphill. The largest signal box in the area was that at Weston-super-Mare East – a standard Great Western hip-roofed cabin with 113 levers. All lines in the area came under the supervision of the Bristol power signal box on the weekend of 29–31 January 1972, and in connection with this scheme the Weston loop was reduced to single track. However, a section of double track was retained at Weston-super-Mare, and a signalling panel at the station could be brought into use to facilitate the local control of the Weston loop in the event of emergencies.

Weston-super-Mare – The Goods Yard

The main goods yard sidings, which incorporated the original 1841 terminus, fanned out in a tangential arrangement at the north end of the curved passenger platforms. Additional sidings on the down side formed part of a coal yard, while a private siding alongside the eastern approaches to the station served the Weston-super-Mare & District Electric Supply Company's power station. Having entered Electric Company property, the power station siding continued as a single line towards the boiler house, coal being unloaded by means of a gantry and hopper. In addition to generating electricity for the town, the power station also supplied electricity at 550V DC for the Weston-super-Mare tramways, the tram depot and power plant being part of the same complex. The car sheds contained six parallel sidings, providing covered accommodation for Weston's entire fleet of double- and single-deck tramcars; in later years, one of the sidings was removed.

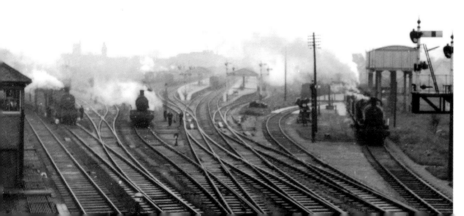

Weston-super-Mare – Locking Road Excursion Station

Above: Locking Road excursion station (closed in February 1967) was situated on the north side of the station between the goods yard and Locking Road itself. It consisted of two double-sided terminal platforms, providing four long platform faces for use by excursion traffic. The platforms were numbered from 1 to 4, and equipped with short canopies. A number of carriage sidings were sited alongside the excursion platforms, although, at the height of the summer season, the platforms were themselves used for berthing empty coaching stock. Until 1937, electric trams had run alongside the excursion station in Locking Road, providing a convenient means of transport to the seafront and piers. The trams were particularly useful when large numbers of people wished to reach Birnbeck Pier in connection with White Funnel steamer services in the Bristol Channel.

Below: Weston-super-Mare boasted a small engine shed housing around three locomotives, although it also dealt with large numbers of visiting engines, especially during the summer holiday season when Locking Road was brought into full use. The shed building was a single-road structure with a low-pitched gable roof. It was of snecked stone construction, and measured approximately 60 feet by 25 feet at ground level. The shed occupied a restricted site between the goods yard and Locking Road excursion platforms, and perhaps for this reason the turntable was sited near the station throat, at some distance from the engine shed.

The allocation in 1921 comprised one 'Duke', one 'Atbara' and one 'Bulldog' class 4-4-0, while in December 1947 the resident locomotives were 'Saint' class 4-6-0 No. 2950 *Taplow Court*, 'Castle' class 4-6-0 No. 5096 *Bridgwater Castle*, and '57XX' class 0-6-0PT No. 7780. A water column was affixed to the side of the engine shed, and others were sited near the turntable and at Locking Road excursion station, in addition to the two columns at the passenger station. Water was supplied from a stilted metal water tower situated beside the turntable siding.

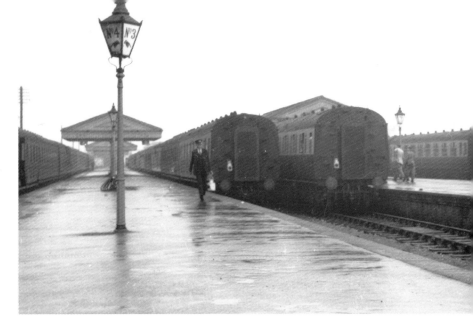

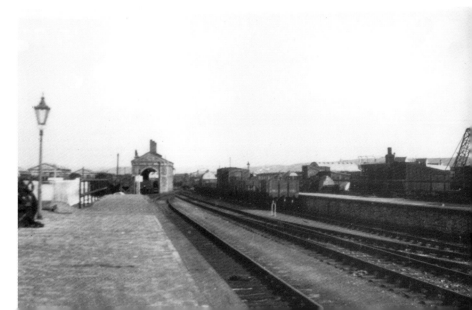

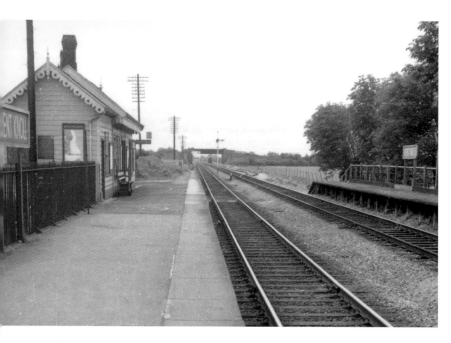

Right: Brent Knoll

Two-car class '116' unit No. C392, comprising motor second No. 51147 and motor brake second No. 51134, passes Puriton on 2 July 1990 with the 1.13 p.m. Worcester Foregate Street to Taunton 'all stations' service. This unit was withdrawn from service in May 1993 but, unlike a lot of its classmates, has since passed into preservation, and is currently residing on the Swansea Vale Railway. Brent Knoll, the conspicuous hillock from which the station derived its name, is unmistakable in the background. This 450-foot eminence is topped by ancient earthworks, including a Celtic hill fort with encircling ramparts.

Left: Brent Knoll

Heading south along dead-level alignments, down services pass the site of a closed halt at Brean Road (140 miles 51 chains), which was opened on 17 June 1929 and closed on 2 March 1953. Beyond, the route continues to Brent Knoll (142 miles 43 chains), the site of a wayside station that had been opened on 1 November 1875. This small station had wooden station buildings and a small goods yard that was able to deal with coal class traffic, livestock and general merchandise. It was closed on Monday 4 January 1971, the last train being scheduled to call on Friday 2 January. By that time, the station was served by just one up train per day – the 7.30 a.m. local service from Taunton to Bristol Temple Meads, which stopped at Brent Knoll at 8.00 a.m. and reached its destination by 8.48 a.m.; in the reverse direction, the balancing 5.45 p.m. down service from Bristol called at 6.34 p.m. and reached Taunton by 7.07 p.m.

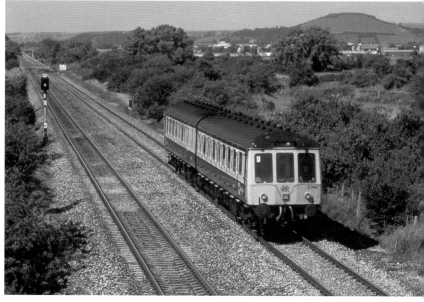

Brent Knoll

Right: Class '56' locomotive No. 56064 passes Lympsham, near Brent Knoll, with the 6.09 a.m. Pathfinder Tours Wolverhampton to Penzance railtour on 8 May 1995. *Below left*: Class '50' locomotive No. 50046 *Ajax* ambles past Brent Knoll with the 8.27 a.m. Bristol East to Taunton departmental working on 1 August 1990. This service would normally have continued south as the 11.05 a.m. Taunton to Exeter Riverside service, but as the three wagons seen in the photograph were dropped off at Taunton, *Ajax* completed its journey to Exeter as a 'light engine'. *Below right*: Class '31' locomotives Nos 31466 and 31420 pass the site of Brent Knoll station at a very respectable 85 mph while hauling the 'Minehead Mariner' railtour on 28 June 1997. This Pathfinder Tours working left York at 5.15 a.m. and travelled through to Minehead via Leeds, Sheffield, Derby, Birmingham, Cheltenham and Bristol.

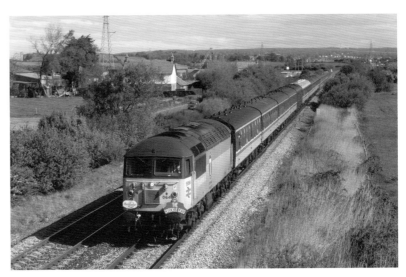

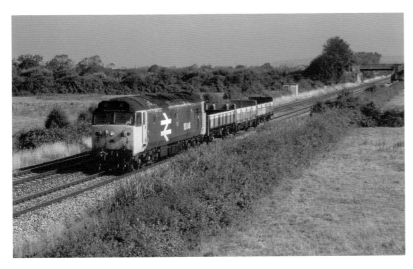

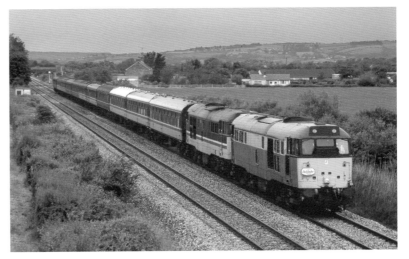

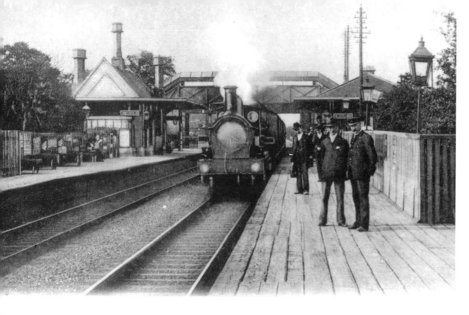

Highbridge – The GWR & S&DJR Stations

Highbridge, the next stopping place (145 miles 23 chains), and was opened by the B&ER on 14 June 1841. It became a junction station on 28 August 1848, when the Somerset Central Railway was opened for public traffic between Highbridge and Glastonbury, with an initial service of six trains each way. The new line was, at first, a broad gauge route, and all trains were worked by the Bristol & Exeter Railway. The line was extended westwards to Burnham-on-Sea on 3 May 1858, necessitating a flat crossing of the B&ER main line.

In 1862, the Somerset Central Railway was amalgamated with the Dorset Central Railway to form the aptly named Somerset & Dorset Railway, and as a corollary of this development the line was converted to the standard gauge of 4 feet 8½ inches. After many vicissitudes, the Somerset & Dorset Railway system was leased to the Midland and London & South Western railways for a period of 999 years under the provisions of an Act of Parliament obtained on 13 July 1876. Having started life as an appendage of the Bristol & Exeter Railway, the Somerset Central line thereby became part of the Somerset & Dorset Joint Railway, and Highbridge acquired two railway stations, the S&DJR station being sited on the east side of the GWR main line.

The upper photograph provides a glimpse of the Great Western station, looking north towards Bristol around 1900, while the lower view shows the neighbouring S&DJR station, looking west towards the GWR line. The Bristol & Exeter platforms were designated platforms 6 and 7, while the up and down S&DJR platforms were designated platforms 4 and 5; the remaining S&DJR platforms were terminal bays. Platform 5 was equipped with a small wooden waiting room, though a more substantial brick-built station building was provided on the opposite side of the station. A concrete footbridge at the west end of the S&DJR station provided a convenient means of access between the S&DJR and GWR platforms.

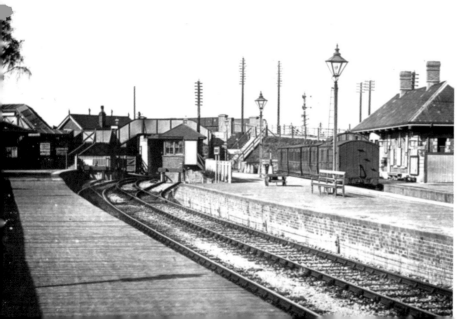

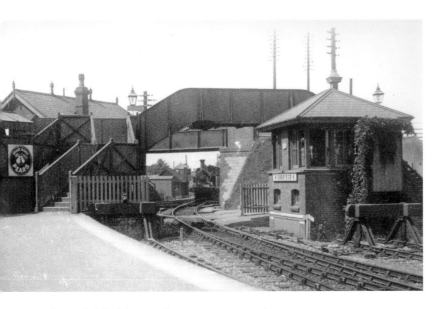

Left: Highbridge – The S&DJR Crossing

A detailed view showing the flat crossing, probably around 1912; an eastbound Somerset & Dorset train is crossing the B&ER main line. The crossing was, at that time, controlled by Highbridge A Box, which can be seen to the right, but this cabin was closed in 1914, and the redundant S&DJR signal box was, thereafter, used as a staff mess room. The gable roof of the B&ER signal box can be seen behind the footbridge; this cabin was replaced as part of the signalling changes carried out in 1914, the replacement box being five-sided, so that it could fit neatly between the diverging GWR and S&DJR lines. Apart from its unusual shape, the new box was of standard Great Western design.

Right: Highbridge – The S&DJR Crossing

This later view, dating from around 1964, shows the concrete footbridge that replaced the earlier bridge. Sadly, the S&DJR system was closed on 7 March 1966, and as this was a Monday the last trains ran over the doomed lines on the preceding weekend. A Locomotive Club of Great Britain farewell tour worked through to Highbridge on Saturday 5 March, the locomotives being Ivatt class '2MT' 2-6-2Ts Nos 41283 and 41307, while a further double-headed special traversed the Highbridge branch on Sunday 6 March; this special, headed by Ivatt class '2MT' 2-6-2Ts Nos 41283 and 41249, was the last passenger train to run on the Somerset & Dorset Joint Railway branch from Highbridge to Evercreech Junction.

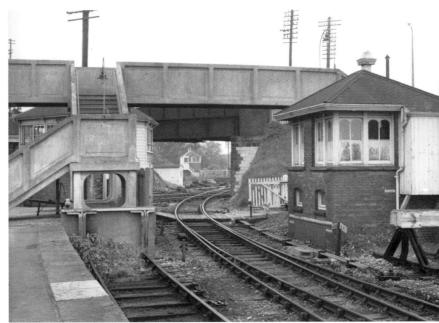

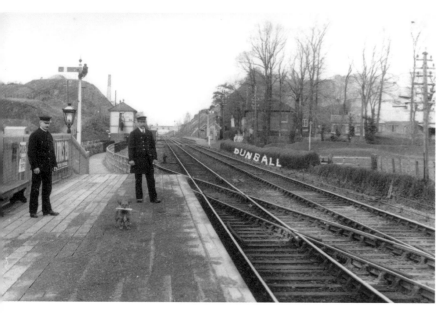

Right: Dunball

Dunball booked around 6,000 tickets each year during the early years of the twentieth century, falling to no more than around 2,000 ordinary bookings per annum during the early to mid-1930s. In 1913, for example, the station issued 6,155 tickets, rising to 6,417 ordinary tickets and twelve seasons by 1923, although in 1937 ticket sales amounted to only 2,031 ordinary tickets and ten seasons. With several private sidings in the immediate vicinity, goods traffic would have been fairly buoyant, although it is not possible to quote any figures because, for operational purposes, Dunball was under the control of neighbouring Bridgwater, and Dunball's freight traffic was included with that from the latter station.

Left: Dunball

Speeding southwards across the north Somerset Levels, down workings reach Dunball (149 miles 5 chains), the site of a station that was opened in June 1873 and closed on 5 October 1964. The platforms here were widely staggered, the up platform being somewhat further south than its counterpart on the down side. The 1938 Railway Clearing House *Handbook of Stations* classifies Dunball as a passenger-only station, although there was a goods-only branch to Dunball Wharf, together with several private sidings. In 1903, Dunball had a staff of six, although the number of employees had been reduced to four by 1919. The photograph is looking north from the up platform during the early years of the twentieth century.

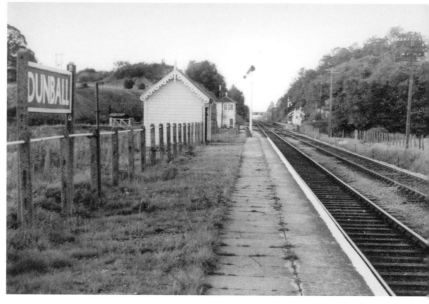

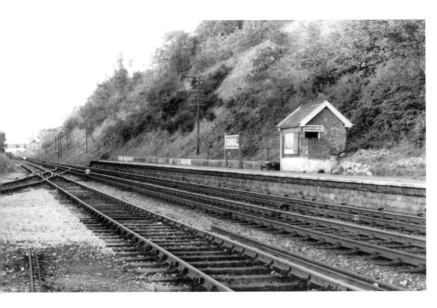

Left: **Dunball**

A detailed view of the staggered down platform. Dunball became an unstaffed halt in November 1961 and the station was closed just three years later. The siding on the left of the picture was part of the Dunball Wharf branch, which commenced at Wharf Junction.

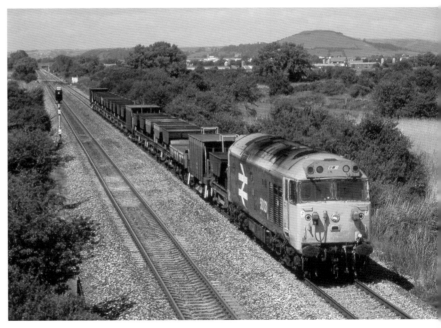

Right: **Dunball**

Class '50' locomotive No. 50031 *Hood* passes the abandoned Puriton Royal Ordnance Factory sidings while approaching Dunball with the 2.37 p.m. Bristol East to Exeter Riverside departmental working on 2 July 1990. The rusting remains of the MoD line are hidden by trees and bushes; this line has since been lifted.

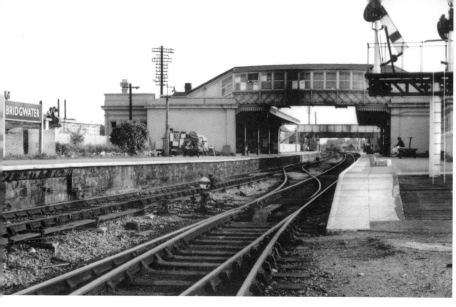

Bridgwater

Maintaining their southerly heading, trains soon reach Bridgwater (151 miles 47 chains), which, like Highbridge, was served by the Somerset & Dorset Joint Railway, as well as the B&ER line. In this case, however, the S&DJR terminus, which was known as Bridgwater North, was sited at some distance from the main line station. Opened on 14 June 1841, Bridgwater has an impressive range of station buildings, the main building being on the up side. In traffic terms, Bridgwater was an important station, 114,865 tickets being sold in 1903, while 112,499 ordinary tickets and 727 seasons were issued in 1923. In 1903, Bridgwater handled 217,827 tons of goods, but there was, thereafter, a slight decline, and by the 1930s the station was dealing with an average of around 170,000 tons per annum. In 1938, the local staff establishment comprised thirty-three at the passenger station, and a further forty-eight in the goods department.

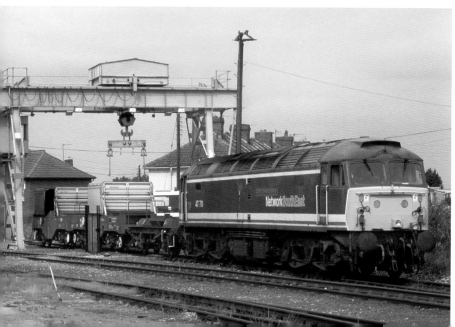

Bridgwater

Prior to rationalisation, Bridgwater had boasted a docks branch and a number of private sidings, which served lineside industries such as the Somerset Trading Company and the British Portland Cement Manufacturers. These industrial sidings have been closed for many years, although a truncated section of the docks branch remains in use as a loading point for nuclear flask traffic from Hinkley Point Power Station. The illustration shows Network South East liveried class '47' locomotive No. 47711 *County of Hertfordshire* at the loading point with the 2.23 p.m. Bridgwater to Sellafield nuclear flask service on 11 September 1997. The final container has just been loaded, and the locomotive will shortly travel the short distance into Bridgwater station, before running round its train and then heading north to Cumbria. No. 47711 was one of the original Scottish push-pull conversions, in which guise it was named *Greyfriars Bobby*. It was later transferred to NSE and worked Paddington to Oxford services until it was displaced by the introduction of class '165' units during the early 1990s.

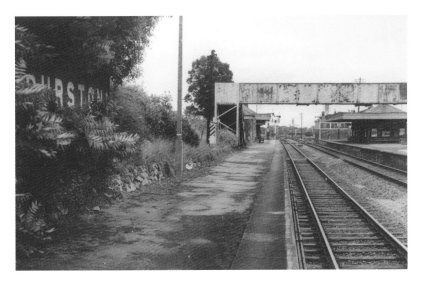

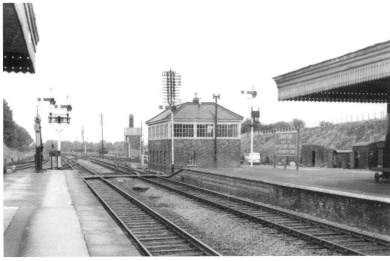

Above left & Above right: Durston

Curving onto a south-westerly alignment, trains reach Durston (157 miles 29 chains), where the Yeovil branch diverged eastwards from the B&ER main line. A new junction was brought into use at nearby Cogload when the Langport cut-off was opened in 1906, but a 2¼-mile section of the earlier route remained in use for local traffic between Durston and Athelney Junction, the Durston loop being the normal route for Yeovil branch trains. The pictures above show Durston station, which was opened on 1 October 1853 and on 5 October 1964. Both pictures are looking north towards Bristol around 1963.

Right: Cogload Junction

Nearing Cogload Junction (157 miles 69 chains), the down line parts company with the up line and southbound trains cross over the Paddington main line on this impressive skew girder bridge, which was constructed in 1932 when the original flat junction at Cogload was replaced by a flying junction. Beyond, trains continue south-west towards Taunton along the B&ER main line.

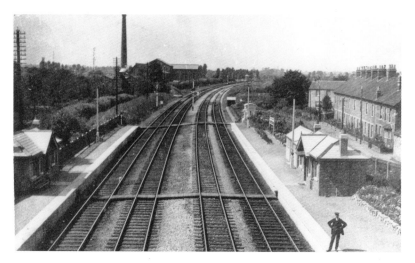

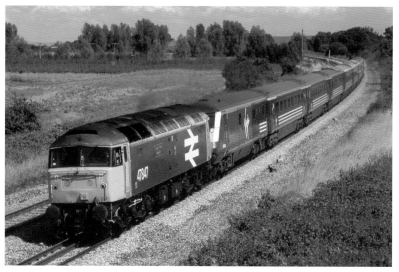

Creech St Michael

There was no station at Cogload, although on 13 August 1928 a halt was opened at Creech St Michael (160 miles 25 chains), about a mile beyond the junction. The platforms here were sited beside the up and down relief lines, there being no requirement for platforms on the main lines. The platforms were 300 feet long, while public access was by means of steps from the adjacent road overbridge. This station closed in 1964.

Creech St Michael was the setting for an accident that occurred on 13 March 1945 when a down express headed by 'Castle' class 4-6-0 No. 5050 *Earl of St Germans* ran into the back of a freight train. The upper left photograph shows the station around 1930, while the upper right-hand view dates from the early 1960s.

Right: Class '47' locomotive No. 47847 passes Creech St Michael with the 9.13 a.m. Liverpool to Plymouth Virgin Cross Country service on 24 August 2002. The train is composed of a West Coast Mk 3 set, with unpowered DVT vehicle No. 82138 directly behind the locomotive.

Taunton – The Northern Approaches

From Creech St Michael the line heads westwards, with the River Tone visible to the left. The photograph shows 'King' class 4-6-0 No. 6024 *King Edward I* running alongside the river with the 11.28 a.m. Pathfinder Tours Newton Abbot to Wolverhampton 'Exe-Tawe' railtour on 25 February 1995.

In steam days, down trains approached Taunton passenger station over a complex web of trackwork, the quadruple tracked main line being flanked by a goods avoiding line and extensive sidings on both sides. The now closed Chard branch diverged southwards at Creech Junction, and the main line then continued westwards to Taunton East Junction, where the goods avoiding lines diverged to the left; Taunton passenger station (163 miles 11 chains) was only a short distance further on. This station was a nodal point at the centre of several diverging routes and, in addition to the West of England main line between Paddington and Penzance, Taunton served as the junction for branch line services to Yeovil, Chard, Barnstaple and Minehead.

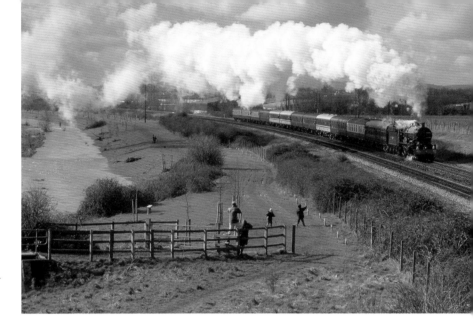

Taunton

When opened in 1842, Taunton had been a single-sided station with separate platforms for up and down traffic on the same side of the running lines, but as traffic continued to increase, the original facilities were progressively improved, and in the 1860s it was decided that the station would be substantially rebuilt. In July 1865, the *Somerset County Herald* confidently predicted that the new facilities would be 'on a sufficiently capacious scale to accommodate the increasing traffic arising from the Chard and Watchet branches'. By the end of the nineteenth century, the remodelled station consisted of up and down platforms for main line traffic and a terminal bay for branch line services, the centre part of the station being spanned by an overall roof with glazed end screens. Further changes were put into effect towards the end of the nineteenth century, when the platforms were lengthened and additional bays were constructed. In connection with this improvement scheme, the neighbouring engine shed was rebuilt, and the goods avoiding lines were installed to the south of the passenger station on the down side.

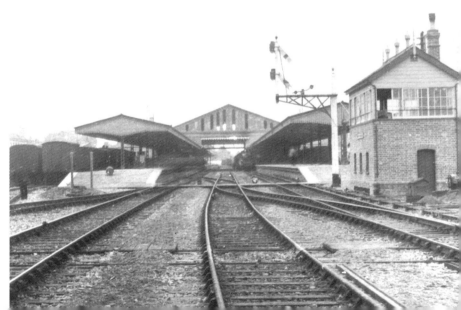

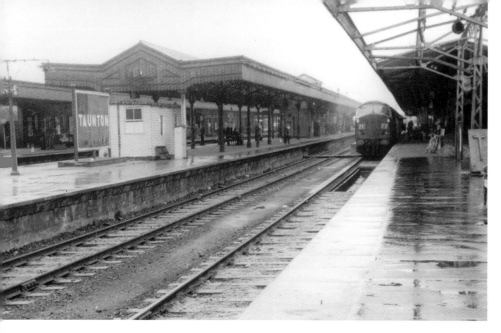

Taunton

The station's Victorian infrastructure was largely swept away as part of a government-financed improvement scheme during the 1930s, when Taunton station was remodelled with four lengthy through platforms. The old down platform was retained as Platform 1 of the new station while, to the north, platforms 5 and 6 were the two sides of a double-sided island platform. A further through platform on the north side of the station was designated Platform 7, while a number of additional bays, numbered 2, 3, 4, 8, 9 and 10, were available for branch line and local services. The platforms were covered by extensive awnings, all of these being adorned with traditional Great Western 'V-and-hole' valancing. The old broad gauge era buildings were retained on Platform 1, but new buildings were erected on the down side and on the central island platform. The longest platform at the rebuilt station had a length of 1,400 feet. The upper picture is looking west along Platform 7, while the lower view shows BR Standard class '9F' 2-10-0 No. 92205 in Platform 1.

As might be expected, the station buildings reflected several different periods of construction. The main down side buildings on Platform 1 were of restrained, classical appearance, the centre part of the building having two full stories. The up side buildings, in contrast, reflected 1930s architectural practice, the main entrance and booking hall having a distinct Art Deco atmosphere. Ticket offices, waiting rooms, toilets, staff accommodation and refreshment rooms were provided on both sides, while additional waiting rooms were available on the island platform. The platforms were linked by an underline subway, the up side ticket office being sited at subway level.

Water columns were available at various points around the passenger station and yards, water being supplied from a large water tower sited to the north of the platforms on the up side. This sported the legend 'VAN HEUSEN' in prominent letters, the Taunton-based firm of Van Heusen's – 'Makers of the World's most famous Semi-Stiff COLLAR' – being a well-known shirt making company.

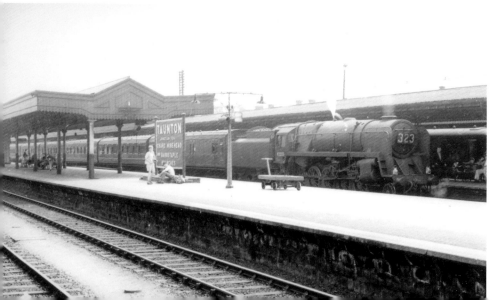

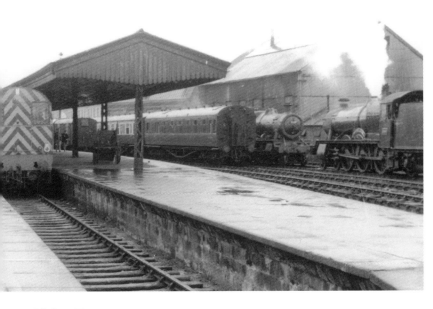

Right: Taunton

A selection of GWR and British Railways tickets from Highbridge, Bridgwater, Taunton and Tiverton Junction stations. Third class was designated 'second class' on Sunday 3 June 1956, although there was no difference in the accommodation provided or the fares that were charged! In BR days, the skeleton letters that had appeared on GWR return tickets were replaced by solid red overprints such as 'R' ('Return'), 'D' ('Cheap Day') or 'M' ('Monthly').

Left: Taunton

Taunton was the site of a large motive power depot, which was coded '83B' in British Railways days. The shed was situated on the down side of the running lines between the passenger station and the goods avoiding lines, and it was of a square roundhouse design, with a central turntable feeding radiating spurs within a large rectangular shed building measuring 185 feet by 185 feet. In January 1948, it contained around fifty-five locomotives of various types, many of these being tank engines and medium-sized tender locomotives for use on the branch lines to Minehead, Chard, Barnstaple and Yeovil; there were, for example, twelve '43XX' class 2-6-0s, two Bulldog 4-4-0s, and seven '2251' class 0-6-0s. There were also a number of Hall, Star and Castle class 4-6-0s for long-distance passenger traffic.

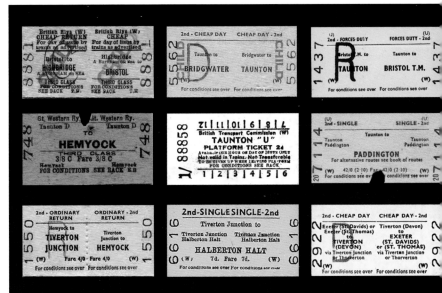

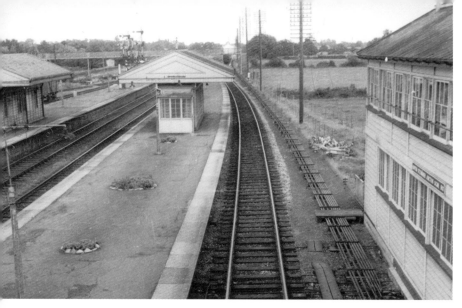

Norton Fitzwarren

From Taunton, trains head westwards along the multiple-tracked main line, and having passed the extensive goods sidings at Fairwater Yard, down workings reach the site of Norton Fitzwarren station (165 miles 8 chains). This station, which was opened on 2 June 1873, was extensively reconstructed during the early 1930s as part of the Great Western's Taunton improvement scheme, and in its rebuilt form the station acquired two island platforms. The Minehead and Barnstaple branches diverged from the main line at the west end of the platforms, the Minehead line having been opened as far as Watchet on 31 March 1862 and completed throughout to Minehead on 16 July 1867, while the Barnstaple route reached Wiveiliscombe on 8 June 1871 and was completed to Barnstaple on 1 November 1873. These two lines were closed in 1963 and 1971 respectively, although the Minehead line was subsequently reopened as a heritage line.

The upper picture shows the station around 1963, while the colour view shows class '31' locomotive No. 33065 *Sealion* passing Norton Fitzwarren with the 11.20 a.m. Meldon Quarry to Tonbridge ballast train on 30 October 1991. Note the Taunton Cider vans on the right; this once important traffic flow managed to survive the end of BR's Speedlink freight service, which had ceased a few months before this picture was taken. However, in 1995, all cider production was transferred to Shepton Mallet, and the Taunton factory was then closed.

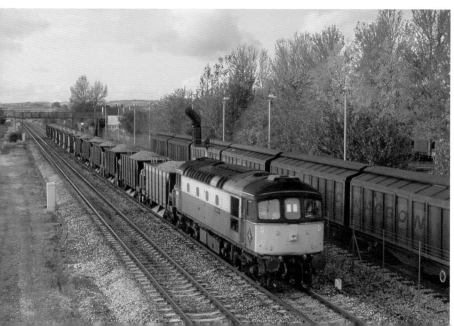

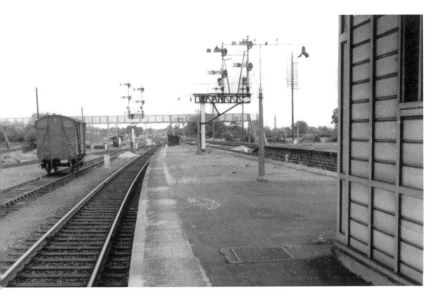

Left: Norton Fitzwarren

A further view of Norton Fitzwarren station, looking east towards Bristol and Paddington during the 1960s. Norton Fitzwarren was closed with effect from 30 October 1961.

Right: Norton Fitzwarren

An HST set headed by power car No. 43025 speeds past Norton Fitzwarren with the 10.15 a.m. Liverpool Lime Street to Plymouth service on 30 October 1991. The huge stacks of cider kegs that can be seen in the distance suggest that Taunton Cider was doing good business during the 1990s.

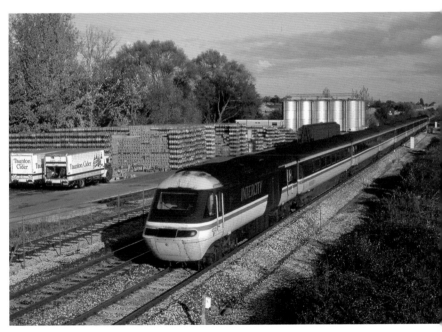

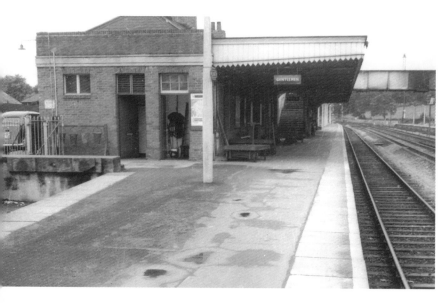

Right: Wellington

Heading south-west, the ascent steepens to 1 in 80 as trains approach the 1,092-yard Whiteball Tunnel, although the inclination eases to 1 in 128 within the tunnel itself. The tunnel straddles the county boundary between Somerset and Devon. On emerging from the western portal, westbound trains run through attractive Devon countryside as the railway descends towards Exeter along the Culm Valley. The photograph, taken on 2 May 1994, shows class '20' locomotive No. 30131 *Almon B. Strowger* and unnamed sister engine No. 20118 passing Whiteball with the 8.33 a.m. Hertfordshire Railtours excursion from Paddington to Exeter St Davids. This was one of a number of railtours that had been arranged in connection with the Exeter Rail Fair. The train was running forty-five minutes late, having been diverted via Bristol instead of Castle Cary as a result of a freight train failure on the Berks & Hants route.

Left: Wellington

Having left Norton Fitzwarren, down trains commence their ascent into the Blackdown Hills. The climb continues for several miles towards Whiteball Tunnel, the gradient steepening to 1 in 163 before Wellington, and 1 in 90 to Beambridge. This section of line was the setting for the famous record-breaking run on 9 May 1904, when No. 3440 *City of Truro* exceeded 100 mph while descending Wellington bank with a northbound Ocean Mail express.

Wellington station (170 miles 21 chains) was opened on 1 May 1843 and closed on Monday 5 October 1964. The station was reconstructed during the 1930s, when the GWR installed up and down platform loops to facilitate the running of additional and faster trains. As a result of this ambitious remodelling scheme, the station acquired a new station building, which was, nevertheless, of traditional design, as shown in the accompanying photograph.

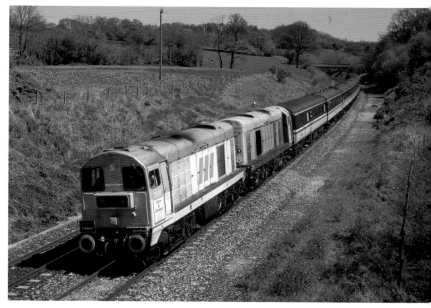

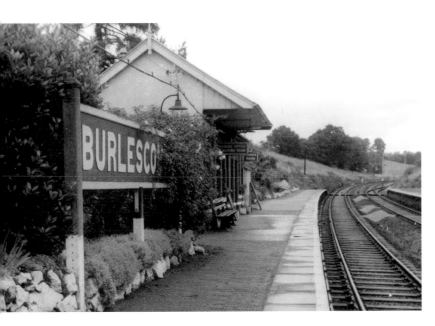

Left: Burlescombe

Sited a short distance to the west of Whiteball Tunnel, Burlescombe station (174 miles 58 chains) was opened in 1867. The station buildings were simple, gable-roofed structures; the main building, on the up platform, was a predominantly brick construction, whereas the down side buildings were built of stone and timber. The goods yard, which was able to deal with coal, livestock and general merchandise traffic, was sited to the south of the platforms on the down side, while refuge sidings were available on both sides, and a private siding served the Westleigh Lime & Stone Company. In common with other wayside stations on the B&ER route, this small station was closed on 5 October 1964.

Right: Burlescombe

'King' class 4-6-0 No. 6024 *King Edward 1* storms northwards along the B&ER main line near Burlescombe while working the 11.28 a.m. Pathfinder Newton Abbot to Wolverhampton 'Exe-Tawe' railtour on 25 February 1995.

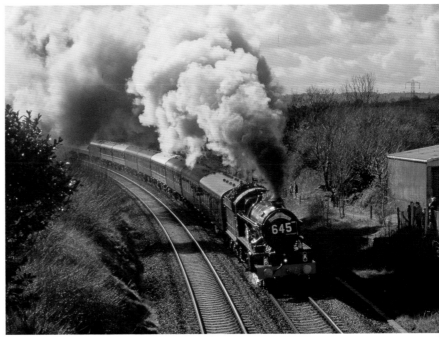

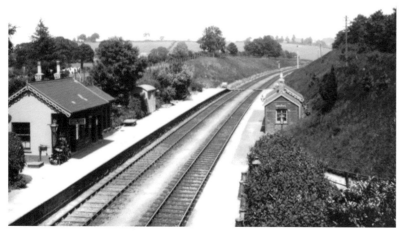

Burlescombe

Left: Burlescombe station, looking northwards from the road overbridge, probably during the early 1920s. *Below left*: A view of the down platform, with its hybrid brick and timber buildings; a goods train can be seen in the down refuge siding, which was sited immediately to the north of the platforms. *Below right*: Class '37' locomotives Nos 37896, 37796 and 37799 near Burlescombe with the 6.15 a.m. Pathfinder Tours Paignton 'Torbay Exe-Cursioner' railtour on 2 May 1994.

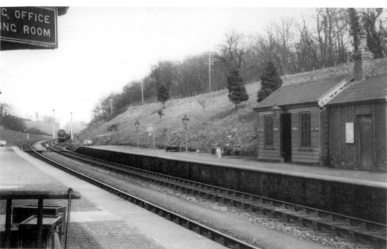

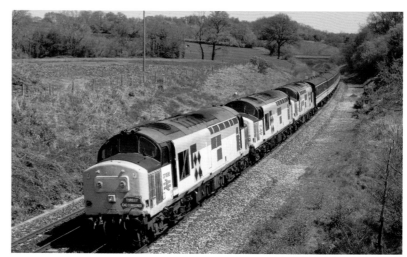

Sampford Peveril (Tiverton Parkway)

Sampford Peveril Halt (177 miles 25 chains) was opened by the GWR on 9 July 1928 and reconstructed in 1932, when up and down refuge loops were installed. The station was closed in October 1964, but it subsequently became the site of a new station known as Tiverton Parkway, which was opened on 12 May 1986. *Right*: Sheep scatter in the adjacent field as class '4MT' 2-6-4Ts Nos 80080 and 80079 approach Tiverton Parkway with the 8.30 a.m. Paddington to Exeter St Davids *Semper Fidelis* railtour on 1 May 1994. *Below left*: Class '37' locomotive No. 37412 *Driver John Elliot* approaches Tiverton Parkway with the 8.15 a.m. Cardiff Central to Newquay 'Cornish Raider' railtour on 30 March 1996. *Below right*: With a contraflow system causing long traffic jams on the nearby M5 motorway, class '47' locomotive No. 47805 approaches Tiverton Parkway with the 3.10 p.m. Birmingham New Street to Penzance Virgin Cross Country service on 14 May 2000.

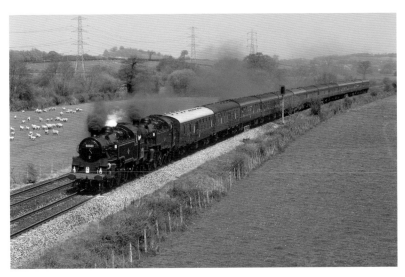

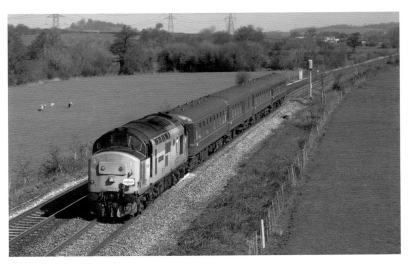

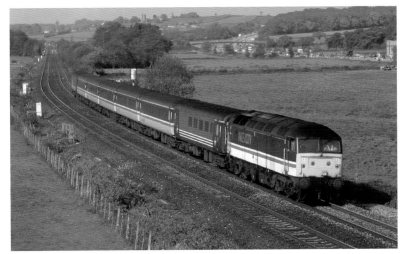

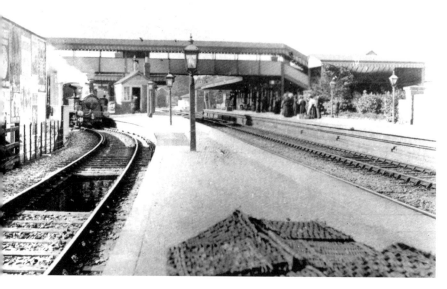

Left: Tiverton Junction – The Original Station

When opened on 1 May 1844, Tiverton Junction (179 miles 10 chains) was known as Tiverton Road, but its name was changed following the opening of the Tiverton branch on 12 June 1848. The station's operational significance was further enhanced when the Culm Valley branch to Hemyock was brought into use on 29 May 1876 and, thereafter, the station developed as a small, but busy interchange point between the B&ER main line and the two branch lines. In its original form, the station had up and down platforms for main line traffic, with separate platforms for branch trains; the Tiverton platform was a terminal bay on the up side, whereas Hemyock trains used a through bay on the east side of the station, the down platform being a double-side island with tracks on either side. The photograph shows the down platform around 1906, with a Hemyock branch train visible to the left.

Right: Tiverton Junction – The Original Station

This *c.* 1906 view, apparently taken from the top of a signal post, shows the up side of the station. The platforms can be seen in the distance, while the single-track Tiverton branch features prominently in the foreground; an 'Achilles' class 4-4-2 locomotive stands on an adjacent siding. The siding that can be seen to the right of the locomotive gave access to a single-road engine shed, the black, timber-built structure being a coaling stage; the engine shed was of brick construction and measured 45 feet by 19 feet at ground level, while the coaling stage measured 26 feet by 13 feet. The cattle pens, to the left of the coaling stage, were served by a lengthy siding, which also served as the up refuge siding. Other features of interest in this Edwardian photograph include the B&ER type signal box, and the substantial stone-built goods shed.

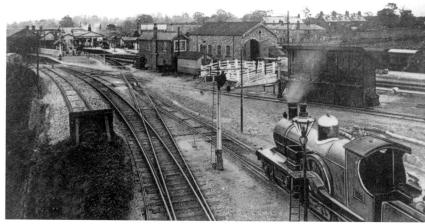

Right: Tiverton Junction – The Rebuilt Station

In 1932, the station was extensively rebuilt as part of the programme of improvements that was carried out with the aid of cheap government loans. The new works at Tiverton Junction were authorised in 1930 and completed by October 1932. Much of the Victorian infrastructure seen in the previous photographs was swept away, and in its place the GWR provided a spacious, quadruple-tracked station with platform loops for stopping services on either side of the up and down running lines. New station buildings were erected, while both platforms became islands, with tracks on each side. The goods yard on the down side was considerably enlarged, with additional sidings and a new goods shed, while on the up side, the B&ER engine shed was replaced by a modern brick shed measuring 65 feet by 20 feet. The photograph is looking northwards along the down platform around 1963.

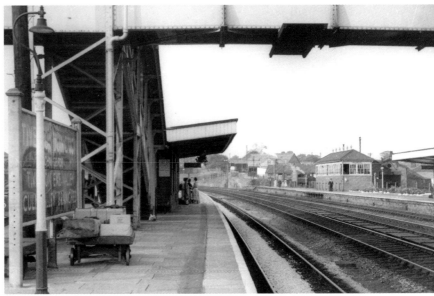

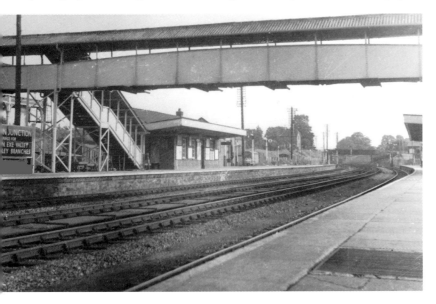

Left: Tiverton Junction – The Rebuilt Station

A view of the new down platform, looking south towards Penzance during the early 1960s. The down side building contained toilets and waiting room accommodation, while the stilted water tank, which is just visible behind the station nameboard, supplied water to water cranes on both sides of the station. The plate girder footbridge was, at first, open to the elements, but in 1946 it was agreed that a roof would be constructed. As well as linking the two island platforms, the footbridge provided a means of access to the station for members of the public.

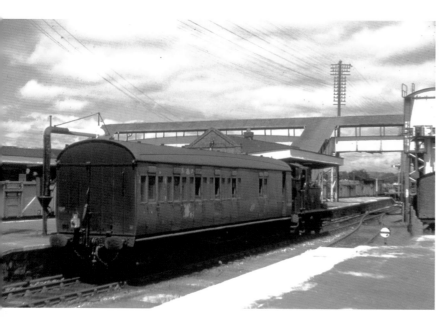

Right: Tiverton Junction

A detailed view of the Hemyock branch bay during the early 1960s; the siding on the extreme left led to the new goods shed. The main station building, which can be seen on the up platform on the right-hand side of the picture, contained (*from left to right*) a gentlemen's urinal; a porters' mess room; the general waiting room; ladies' room; booking office and the stationmaster's office.

Opposite: Tiverton Junction – The Hemyock Branch Train

A detailed view of the Hemyock branch train on 13 June 1962.

Left: Tiverton Junction

The Hemyock branch train waits in its platform on the down side on 13 June 1962. The passenger vehicle appears to be a former Barry Railway brake third, with five second-class compartments in addition to the luggage/guard's compartment. Prior to 1932 there had been no run-round facilities for Culm Valley branch trains and, for this reason, trains would reverse out of the station after passengers had alighted and, the engine having been detached, the empty coaches would then run back into the bay platform under the control of the guard's handbrake. As a result of the 1932 alterations, however, a connection was installed at the south end of the branch platform line, so that engines could run round on the down platform line.

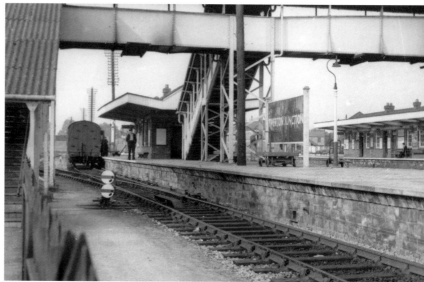

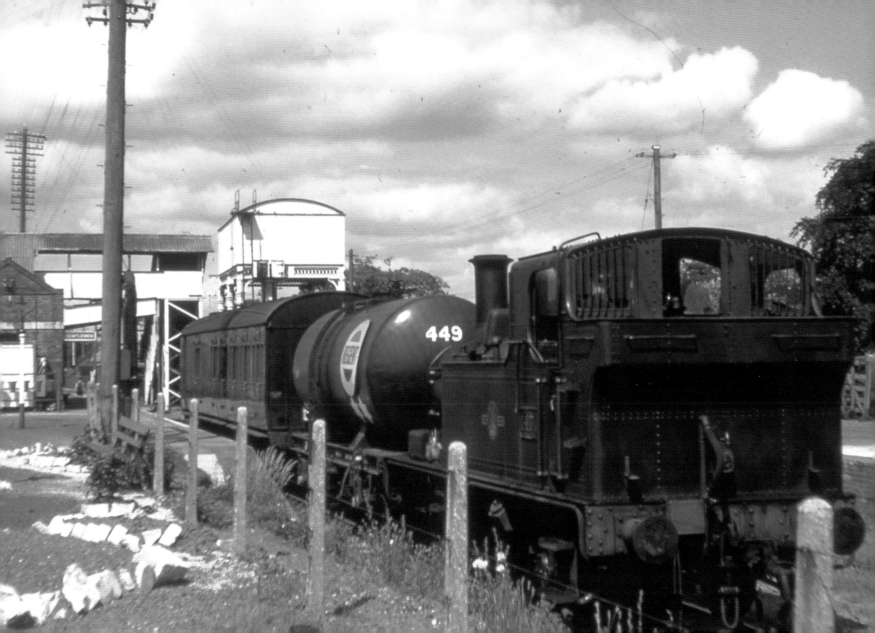

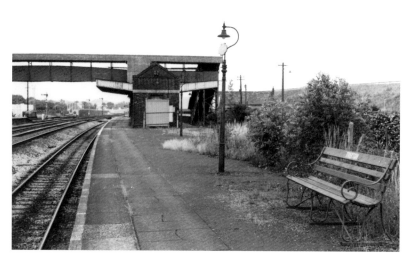

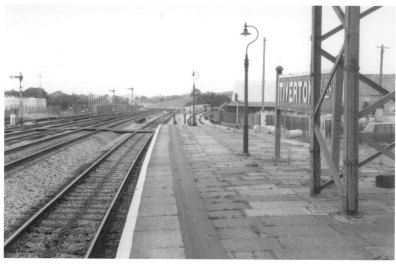

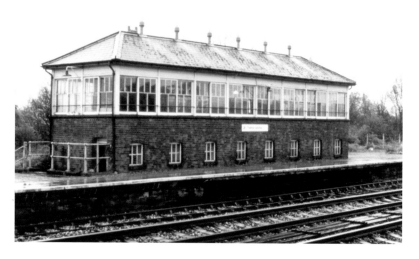

Tiverton Junction

The local railway system was run down during the 1960s, the Culm Valley line being closed to passengers with effect from 9 September 1963. As there was no Sunday service, the last passenger trains ran to Hemyock on Saturday 7 September 1963, although the Culm Valley line remained open for several years thereafter in connection with milk traffic. The Tiverton branch became a victim of the 5 October 1964 closures, while Tiverton Junction was itself closed in 1986, when it was replaced by the new station at Tiverton Parkway. The black-and-white photographs depict the station in its declining years, while the colour view shows Tiverton Junction Signal Box, which was sited on the up platform, and had a 125-lever frame (including spares).

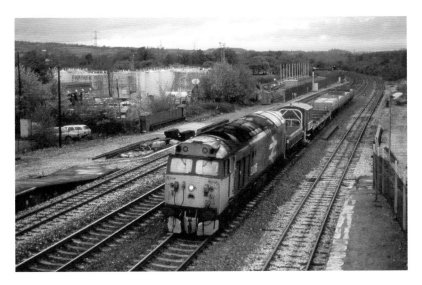

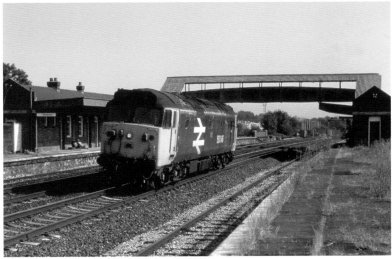

Tiverton Junction

Above left: Class '50' locomotive No. 50015 *Valiant* passing through the closed station with the 8.27 a.m. Bristol East to Exeter Riverside departmental working on 14 November 1990. This photograph was taken from the footbridge; note the oil depot in the background of this picture, which had recently had its rail connection removed. *Above right*: Class '50' locomotive No. 50046 *Ajax* passes through the closed Tiverton Junction station on 1 August 1990 with the 11.05 a.m. Taunton to Exeter Riverside departmental working. *Right*: Class '50' locomotive No. 50032 *Courageous* is still wearing the original version of Network South East livery, albeit in extremely scruffy condition, as it passes Willand with the 2.37 p.m. Bristol East to Exeter Riverside departmental working on 1 August 1990. Tiverton Junction station was sited just beyond the road overbridge that can be seen in the background.

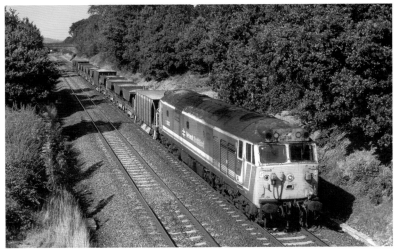

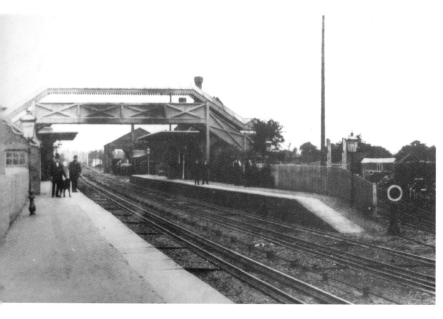

Left: Cullompton

From Tiverton Junction, the line heads southwards to Cullompton (181 miles 26 chains). This station was opened on 1 May 1844, and in its original guise it featured a typical Brunelian Tudor-Gothic-style station building. However, like most of the other stopping places on this section of the line, Cullompton was extensively rebuilt during the early 1930s, when the GWR constructed a quadruple-tracked station in place of the earlier Victorian infrastructure. Modern brick-built station buildings were erected on the resited platforms, these new structures being similar in appearance to those provided at Parson Street, Wellington and Tiverton Junction stations. The picture, which dates from around 1890, shows the original, two-platform station, with mixed gauge trackwork still in situ.

Right: Cullompton

Cullompton was closed to passengers on Monday 5 October 1964, the station having become yet another victim of the 1964 purge. The photograph, taken on 1 August 1990, shows class '50' locomotive No. 50042 *Triumph* ambling through the abandoned station with the 2.37 p.m. Bristol East to Exeter Riverside departmental working; No. 50042 was withdrawn from service just two months later. The old goods shed and derelict platforms are still in situ, while a solitary post from one of the nameboards still survives among the weeds on the up platform. This scene has now been utterly transformed, the station site having been redeveloped as a motorway service area.

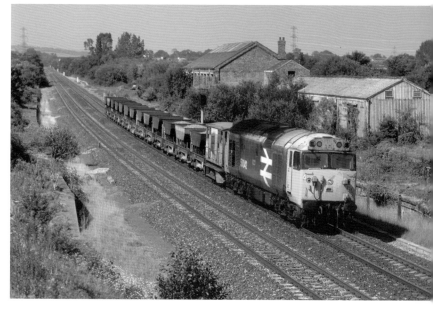

Cullompton

Right: A view of Cullompton station prior to closure, looking south towards Penzance. *Below left*: Class '45' locomotive No. D172 *Ixion* passes the site of Cullompton station on 23 September 1995 with the 5.30 a.m. Pathfinder Tours Coventry to Penzance 'Cornishman' railtour on 23 September 1995. At that time, the old down platform was an ideal spot for photographing southbound trains. *Below right*: Standard class '4MT' 2-6-4Ts Nos 80079 and 80080 race the M5 motorway traffic at Cullompton on 2 May 1994 with the Flying Scotsman Services 18.10 Exeter St Davids to Paddington *Semper Fidelis* railtour, which they worked as far as Bristol Temple Meads.

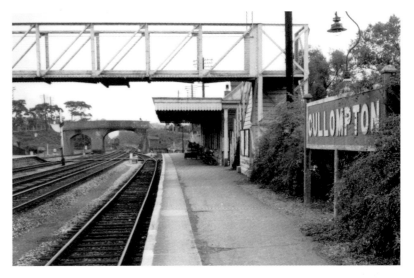

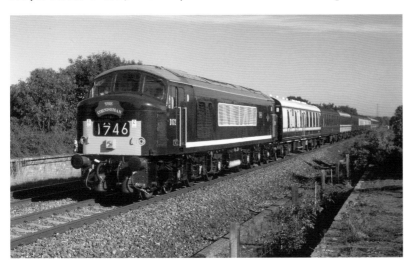

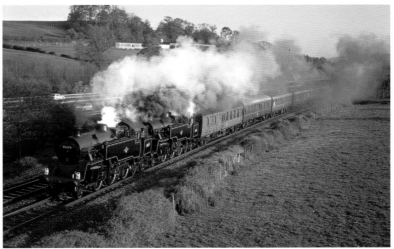

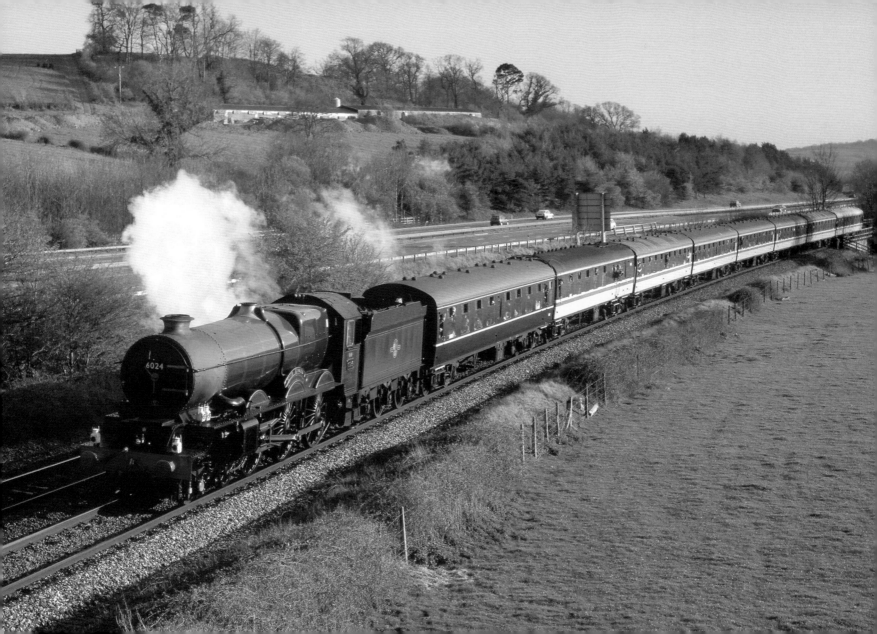

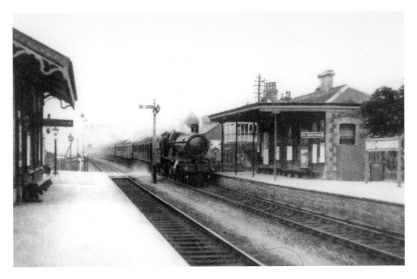

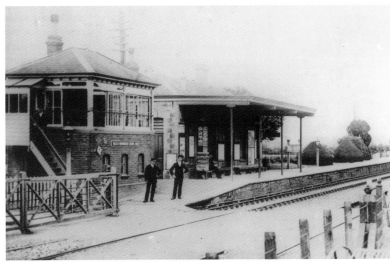

Hele & Bradninch

Curving onto a south-westerly heading, the B&ER route continues to Hele & Bradninch (185 miles 43 chains), which was known simply as Hele when it was opened on 1 May 1844, but became Hele & Bradninch in 1867. The two upper photographs show the station during the Edwardian period, while the lower view shows the north end of the platforms during the 1960s. Hele & Bradninch was one of over sixty Western Region stations removed from the BR network by Transport Minister Ernest Marples over the weekend of 3/4 October 1964, no less than ten of these doomed stopping places being on the Bristol & Exeter line.

Opposite: Cullompton

'King' class 4-6-0 No. 6024 *King Edward I* runs alongside the M5 motorway at Cullompton at the head of the 3.05 p.m. Pathfinder Tours 'King of the Banks' railtour, which ran from Plymouth to Birmingham International on 5 April 1997.

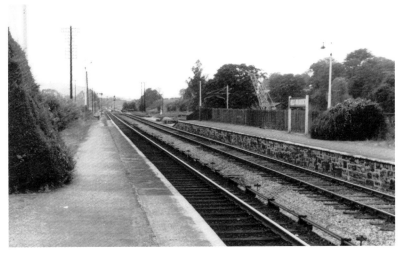

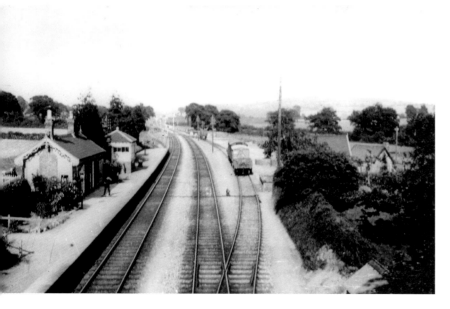

Left: Silverton

Silverton, the next station (186 miles 61 chains), was a little over 1 mile from Hele & Bradninch. The station was opened on 1 November 1867 and, like Dunball, it featured staggered platforms – the up platform being further north than the platform on the down side. The main station building was on the up platform, and this small but attractive structure was of timber-framed construction, with a gable roof and ornate barge boards. The Railway Clearing House *Handbook of Stations* reveals that the station could handle coal and general merchandise traffic, while the goods yard was equipped with a 4-ton crane. A private siding was opened in 1894 in connection with Messrs Reed & Smith's paper mill.

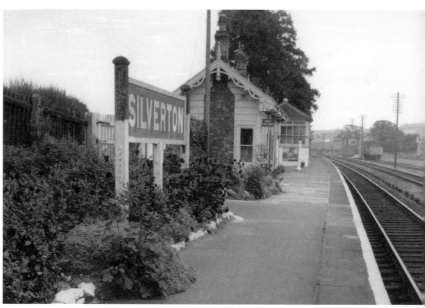

Right: Silverton

Great Western Railway traffic statistics reveal that Silverton issued 8,656 tickets in 1903, the corresponding figures for 1913 and 1923 being 7,030 and 8,594 respectively. Thereafter, there were around 6,000–7,000 ordinary ticket sales per annum, although the fact that up to 100 season tickets per year were sold during the 1930s would indicate that many regular travellers preferred to pay for their journeys in this convenient way. In 1933, the station issued 8,098 ordinary tickets and 126 season tickets, while in 1936, 6,245 tickets and 94 seasons were issued. Silverton also dealt with considerable amounts of goods traffic via its private sidings; in 1930, for instance, the station dealt with 46,311 tons of freight, rising to 50,022 tons in 1937.

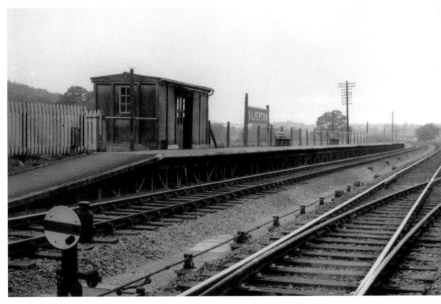

Right: **Silverton**
A detailed view of the staggered down platform, which was of segmental concrete construction. This station was closed to passengers on 5 October 1964, and goods facilities were withdrawn in May 1965 – the private siding traffic lasted until 1967.

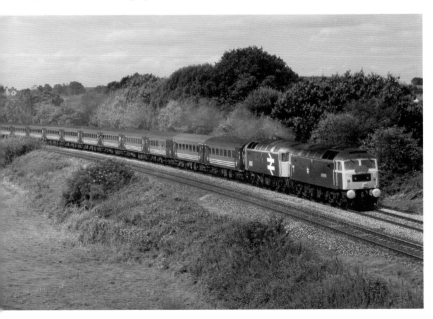

Left: **Silverton**
Class '47' locomotives Nos 47840 *North Star* (renumbered 47077 for the occasion) and 47847 *Railway World Magazine/Brian Morrison* pass Silverton with the 8.46 a.m. Penzance to Manchester Piccadilly service on 19 August 2002. This was the final Virgin Cross Country locomotive-hauled trains prior to the start of total Voyager operation – the headboard reads 'Cross Country Locomotive Farewell'.

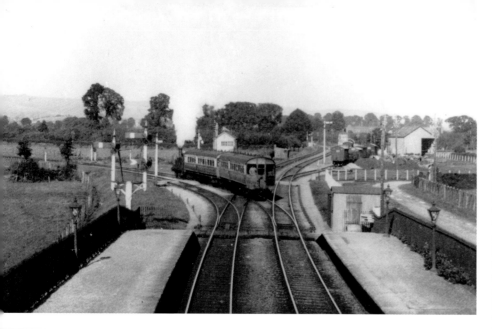

Stoke Cannon

Stoke Cannon station, some 4 miles further on, was being used as wayside stopping place as early as 1852, although the original facilities must have been primitive in the extreme. A proper station, with staggered up and down platforms and a small goods yard, was opened on 21 May 1862, but problems arose when the Exe Valley Railway was promoted during the 1870s. The Exe Valley Railway Bill, which was submitted to parliament in November 1873, sought consent for a railway commencing at Tiverton and terminating 'in the Parish of Stoke Cannon … by a junction with the Bristol & Exeter Railway at a point thereon distant about 8 chains in a northerly direction from the mile-post denoting 189½ miles from London.' However, when opened on 1 May 1885, the new branch line joined the B&ER main line near the 190½-mile post, which meant that Stoke Cannon station was on the 'wrong' side of the junction! This situated was rectified on 21 July 1894 when a new passenger station was opened to the south of the junction, although the original goods yard remained in use on the down side. Further changes were put into effect during the early 1930s when Stoke Cannon was rebuilt as a quadruple-tracked station with up and down platform loops for stopping trains and fast lines for through traffic.

The upper photograph, taken from the footbridge of the 1894 station, is looking north towards Bristol in October 1924. An auto-train is running into the station with an Exe Valley branch working, while the goods yard can be seen alongside the B&ER main line. The lower view, which was probably taken at the same time as the previous picture, is looking south from the footbridge. Sadly, Stoke Cannon was closed to passengers on 13 June 1960, while goods facilities were withdrawn in May 1965.

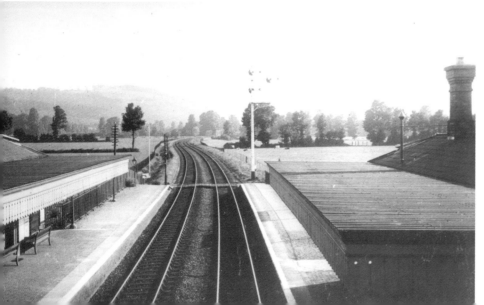

Exeter – Cowley Bridge Junction

From Stoke Cannon, the B&ER route continues south-westwards to Cowley Bridge Junction (192 miles 52 chains), at which point the North Devon line from Barnstaple converges with the main line. Running for almost 40 miles through the rural heart of Devon, the North Devon route was built by two companies: the initial section was opened by the Exeter & Crediton Railway on 12 May 1851, while the line was completed throughout to Barnstaple on 1 August 1854, when the North Devon Railway was brought into use. Both of these undertakings eventually passed into London & South Western ownership although, as a result of earlier alliances, L&SWR trains had to run through Exeter St Davids station and over part of the GWR system in order to reach the Exeter & Crediton route at Cowley Bridge. In steam days, the North Devon line had left the Paddington to Penzance route by means of a conventional double-track junction, as shown in the photograph, but in 1966 a single-track connection was provided as part of an alteration scheme that involved the replacement of four life-expired girder bridges.

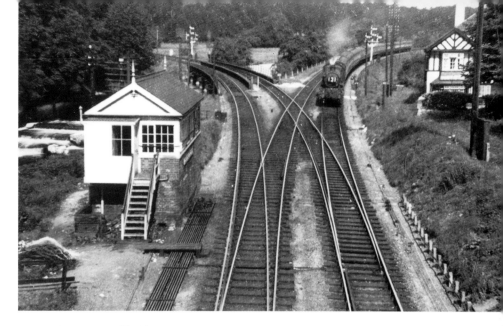

Exeter St Davids

Exeter St Davids (193 miles 72 chains) is only a short distance further on, the northern approaches to this busy station being flanked by the extensive Riverside goods sidings, which can be seen to the right of the running lines as trains enter the outskirts of Exeter. Opened by the Bristol & Exeter Railway on 1 May 1844, St Davids station was, for many years, covered by a cavernous overall roof, which can be seen in this Victorian view of an 'Achilles' class 4-2-2 leaving the station with the *Flying Dutchman*. The train shed was taken down when the station was rebuilt during the early years of the twentieth century, but one of the massive retaining walls that had supported the overall roof was retained, and this was fitted with a distinctive glazed screen, which can be seen in some of the accompanying photographs.

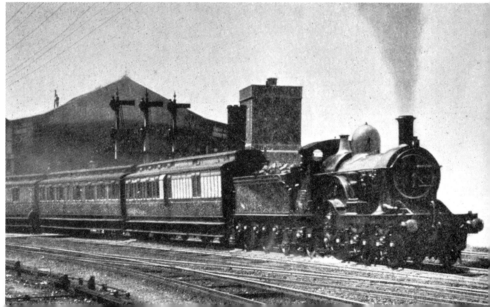

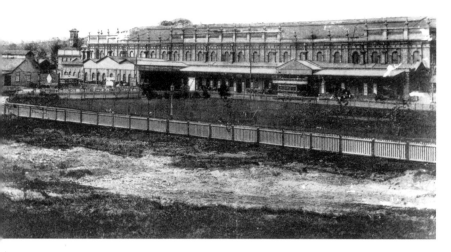

Left: **Exeter St Davids**

This *c.* 1910 postcard shows the main station buildings, which are on the down (or westbound) side of the line. These substantial buildings were designed by Francis Fox, the B&ER engineer, and completed in 1864. The overall roof was, at that time, still in place, although demolition had been completed by 1913. The present-day station has six platforms: Platform 1 is the original down platform on the east side of the station, Platform 2 is a terminal bay at its northern end and platforms 3 and 4 are the two sides of a central island platform – Platform 4 being the main down platform used by InterCity services to Plymouth and Penzance. Platforms 5 and 6 are the two sides of another island platform on the western side of the station. The platforms are linked by two spacious footbridges, one of which is equipped with a luggage lift.

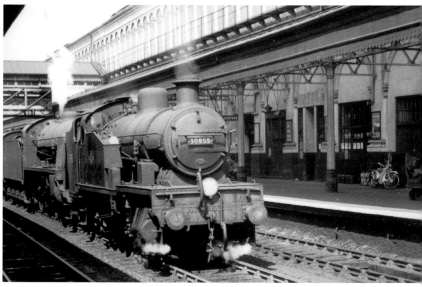

Right: **Exeter St Davids**

The interior of the station during the early 1960s, showing details of the glazed roof covering and screen on Platform 1. Former Southern Railway 'Z' class 0-8-0T locomotive No. 30955 is standing on the centre road between platforms 1 and 3, having just been coupled onto a Southern Region parcels train. These sturdy locomotives were employed as bankers in order to assist SR workings up the fearsome 1 in 37 incline, which connects Exeter St Davids with the former London & South Western station at Exeter Central. In pre-nationalisation days, Southern services used the central island platform, SR staff being deployed to check passengers' tickets at the bottom of the stairs from the footbridge.

Exeter St Davids

Above: Southern Railway 'N' class 2-6-0 No. 1894 is pictured departing from Exeter St Davids during the 1930s; this locomotive became No. 31894 after nationalisation. Curiously, although Exeter to Waterloo trains are classified as up workings, they depart from Exeter St Davids in a southbound direction, whereas Paddington services heading towards London via the GWR route leave the station in a northerly direction; in other words, Exeter St Davids is one of the few stations where London trains depart in opposite directions from either end of the platforms!

Below: An unidentified class '52' diesel-hydraulic waits in Platform 3 with a down West of England service on 23 July 1974. Exeter St Davids has always been a busy station. In 1913, for example, it issued 270,265 tickets, the corresponding figures for 1923 and 1929 being 320,332 and 376,881 respectively. There was, thereafter, an apparent decline in the number of ordinary bookings, around 250,000 tickets being issued per annum during the mid- to late 1930s. On the other hand, over 4,000 season tickets were sold each year during the late 1930s, indicating that many regular travellers preferred to pay for their journeys in this convenient way. In 1938, the station issued 218,160 ordinary tickets and 4,623 seasons, while parcels traffic amounted to around 340,000 parcels and miscellaneous packages per annum during the period from 1933 to 1938.

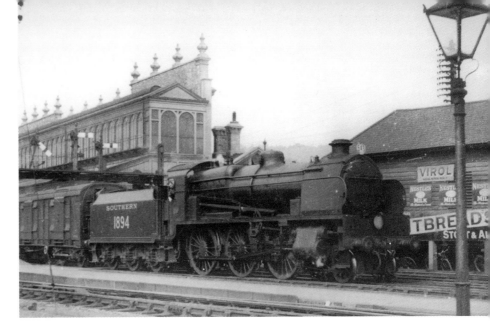

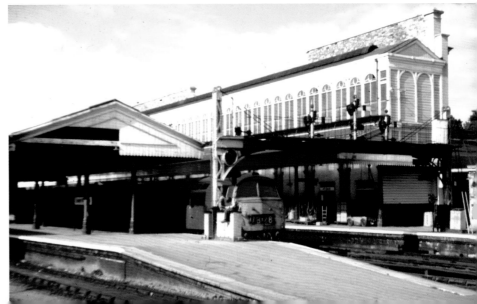

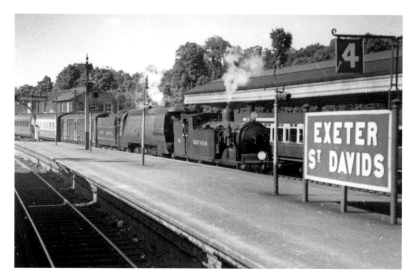

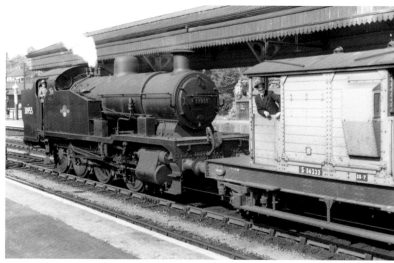

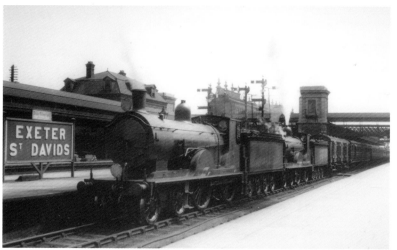

Exeter St Davids

Above left: A Southern Region express passenger working enters Platform 3 during the early British Railways period, around 1949. The train engine is one of Oliver Bulleid's 'Light Pacifics' with their distinctive 'air-smoothed' casings, while the assisting engine is 'M7' class 0-4-4T No. 49; the 'M7' is still in Southern Railway livery, although some of the coaches have already been repainted in the then new British Railways crimson and cream livery. *Above right*: Southern Region 'Z' class 0-8-0T No. 30955 stands on the centre road between platforms 3 and 4 with SR brake van No. S56223. *Right*: A Southern Railway passenger working, double-headed by two Drummond 'T9' 4-4-0s, waits alongside the centre island platform around 1948.

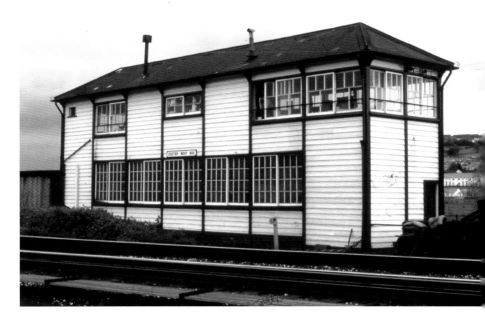

Exeter St Davids

Above: A detailed view of Exeter West Signal Box in May 1983. This all-timber box was sited at the west end of the platforms in the 'V' of the junction between the main line and the connecting line to Exeter Central; the picture shows the rear of the box, which was fitted with additional windows so that signalmen could obtain a good view of the Exeter Central line. When opened in 1913, the box contained a 114-lever frame. A 131-lever frame was installed in 1959. Exeter West and Middle boxes were taken out of use in 1985 as part of the Exeter multi-aspect resignalling scheme, but the West box was later re-erected as a museum exhibit at the Crewe Heritage Centre.

Below: The main goods yard was situated to the north of the platforms on the up side, and its infrastructure included a large wooden goods shed, together with a brick-built Italianate shed, dating from the 1860s, that had once served as a transfer shed between the broad and standard gauges. Exeter St Davids dealt with around 100,000 tons of freight per annum during the early 1900s, increasing to about 212,000 tons per year during the 1920s and 1930s; in 1936, for example, Exeter handled 220,103 tons, while in 1937 the station dealt with 221,392 tons of freight.

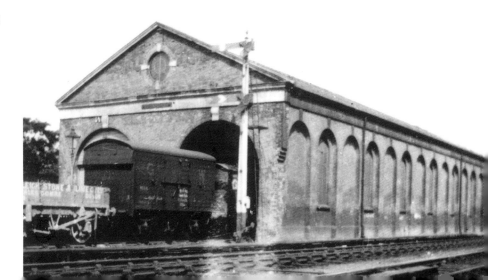

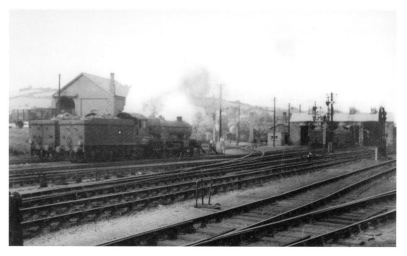

Exeter St Davids

Left: Exeter St Davids engine shed was sited immediately to the west of the platforms, a four-road northlight-pattern shed being available, along with the usual coaling stage, offices and stores. The shed measured approximately 195 feet by 70 feet, while the adjacent lifting shop measured around 106 feet by 30 feet at ground level. In January 1947, the allocation comprised five 'Castle' class 4-6-0s, one 'County' class 4-6-0, three 'Bulldog' class 4-4-0s, three '28XX' class 2-8-0s, four '63XX' class 2-6-0s, one '44XX' class 2-6-2T, three '45XX' class 2-6-2Ts, five '14XX' class 0-4-2Ts and nine pannier tanks of various types. *Below left*: A detailed view of Exeter Middle Signal Box. *Below right*: A typical array of Great Western lower quadrant signals on a gantry at the north end of the station; the goods shed can be seen at the rear of the platforms.

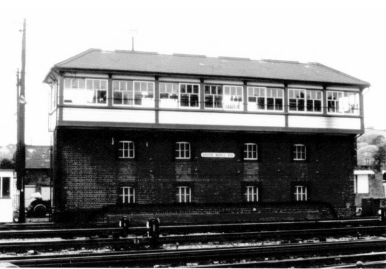

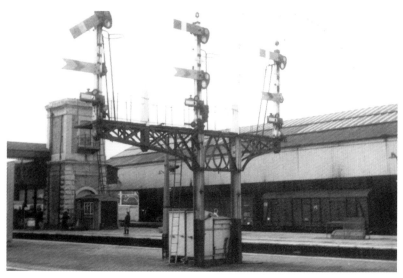

Exeter St Davids

Right: A Southern Region train runs into Exeter St Davids on the sharply curved line from Exeter Central; Exeter West Signal Box can be seen to the right. The locomotives are BR Standard class '4MT' 2-6-2T No. 82013 and 'E1/R' class 0-6-2T No. 32135, the latter being a veteran London, Brighton & South Coast Railway 0-6-0 tank locomotive that was rebuilt as an 0-6-2T in 1928. *Below left*: Hymek class '35' diesel-hydraulic locomotive No. D7011 in the engine sidings at Exeter St Davids on 23 July 1974. *Below right*: Class '35' locomotive No. D7011 and an unidentified class '52' locomotive stand in the engine sidings on 23 July 1973.

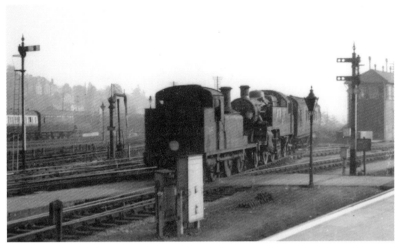

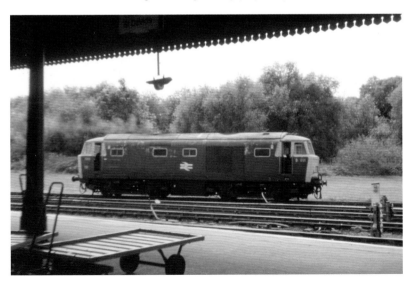

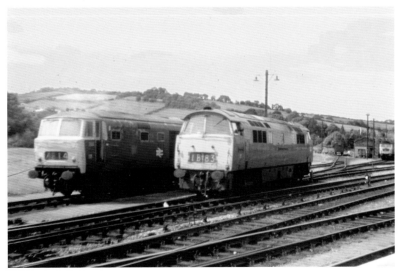

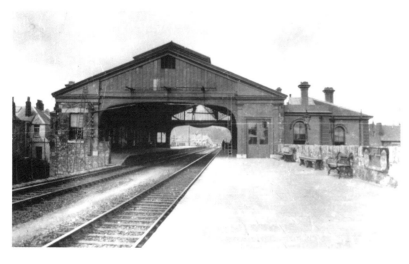

Exeter St Thomas

On leaving Exeter St Davids, trains proceed south-eastwards along the former South Devon Railway, which, as mentioned earlier, was planned as an 'atmospheric' railway, with gradients much steeper than those found elsewhere on the West of England main line. However, Brunel laid out the easternmost part of the SDR route along the estuaries of the rivers Exe and Teign, and along the sea wall from Dawlish Warren to Teignmouth, and the first 25 miles are, in consequence, virtually dead level. *Above*: Exeter St Thomas (194 miles 66 chains), the first intermediate station on the South Devon section, was opened on 30 May 1846. The station is perched on top of a viaduct, which was widened in 1861, necessitating the provision of new station buildings and a larger train shed, the latter structure being of typical Brunelian design, although Brunel had died two years earlier. The accompanying photograph was probably taken during the 1920s. *Right*: The interior of the train shed during the early 1960s.

Opposite: Exeter St Thomas

A general view of Exeter St Thomas station during the early years of the twentieth century. The platforms were lengthened in 1929/30.

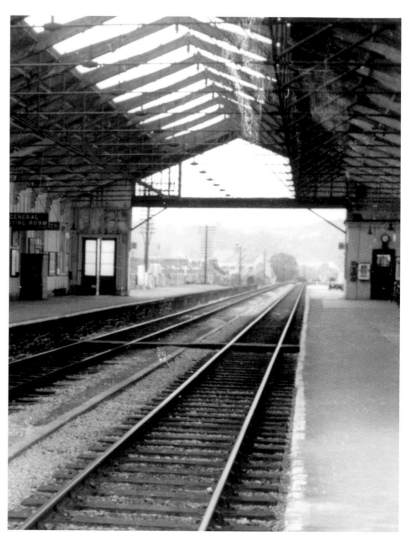

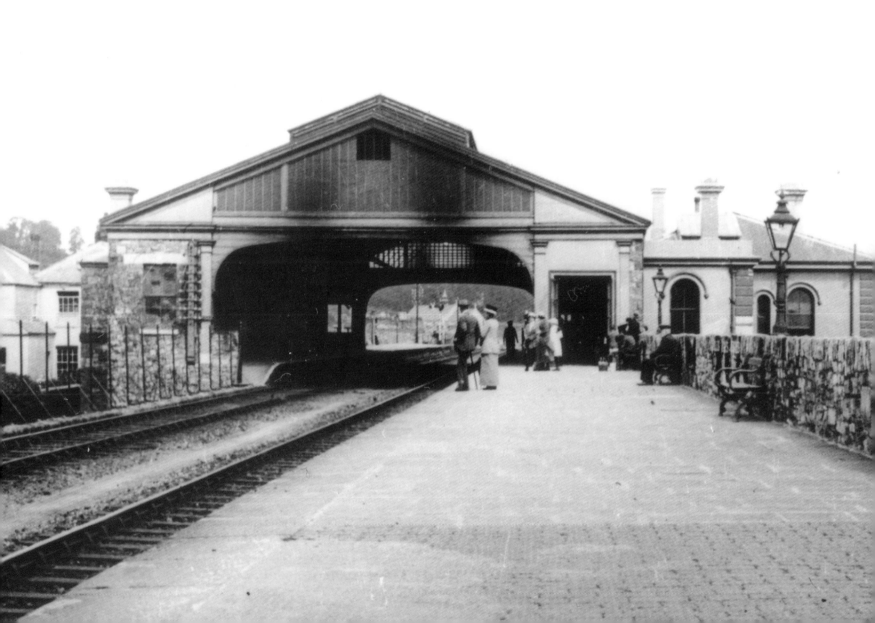

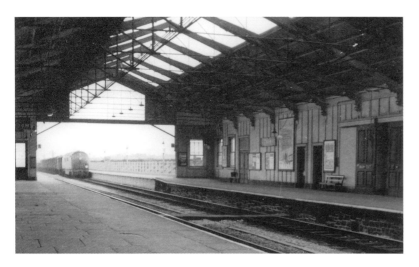

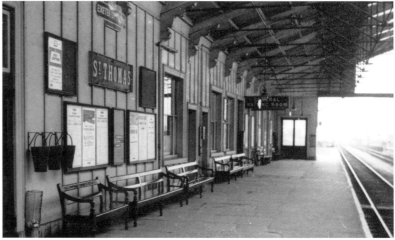

Exeter St Thomas

Above left & above right: These two photographs show the interior of the train shed around 1962. Exeter St Thomas was a passenger-only station, but in 1865 a short, goods-only branch was authorised as a link between the SDR and the nearby Exeter Canal basin. This mixed gauge line, which diverged from the main line near St Thomas station at Exeter Basin Junction (195 miles 32 chains) was opened in June 1867, and it served a number of lineside industries, together with the Alphington Road Goods Depot. The 1938 Railway Clearing House *Handbook of Stations* reveals that several private sidings were, at that time, in operation on the Exeter Basin branch, including Claridge's Timber Yard siding, the Exeter Gasworks siding, the Vulcan Stove Company Siding and 'the Exeter Corporation generating station siding'. *Right*: A view of the main station building on the down side.

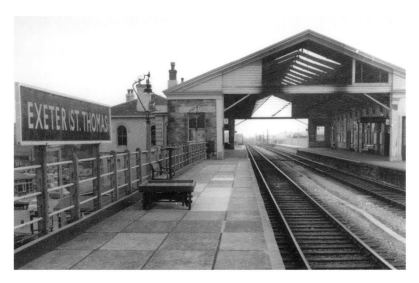

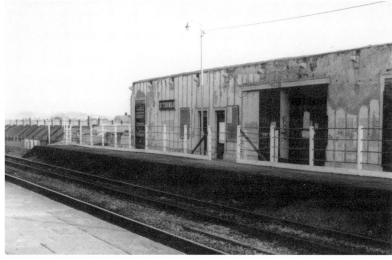

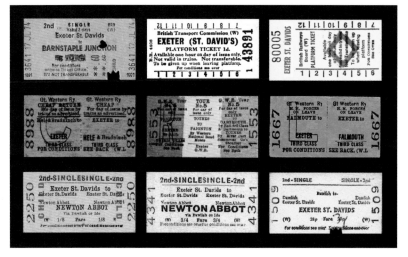

Exeter St Thomas

Above left: A general view of Exeter St Thomas station during the early 1960s. The classic Brunelian style train shed lasted until the summer of 1970 when, sadly, it was dismantled, together with the up side station building. The down side building has survived and has become a Chinese restaurant. *Above right*: A view of Exeter St Thomas after the removal of the train shed. Despite the loss of some of its infrastructure, Exeter St Thomas remains a comparatively busy station, which, in the early twenty-first century, was generating around 60,000 passenger journeys per annum, rising to 196,198 by 2012/13. *Right*: A selection of tickets from the eastern end of the SDR line between Exeter and Dawlish, including two British Railways platform tickets and a Great Western rail–road–river excursion ticket.

Right: **Exminster**

Running south-eastwards alongside the Exeter Canal, with the River Exe visible away to the east, down services pass the site of Exminster station (198 miles 59 chains), which was opened in 1855 and closed on Monday 30 March 1964. The upper view shows class '37' locomotive No. 37675 *William Cookworthy* and unnamed sister engine No. 37673 passing the boarded up signal box at Exminster while hauling the 3.35 p.m. St Blazey to Gloucester 'Speedlink' freight service on 22 April 1988. Although only a short train, this was a true mixed traffic working that contained seven different types of wagon. Both locomotives were, at that time, allocated to Plymouth Laira, and they regularly appeared on this service.

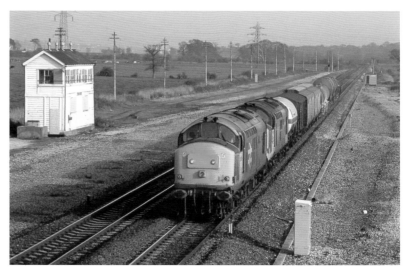

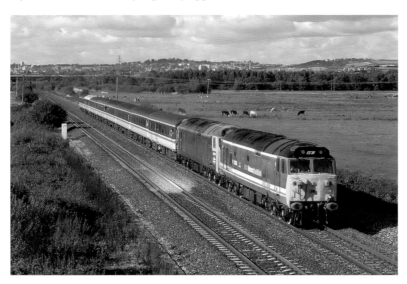

Left: **Exminster**

Class '50' locomotives Nos 50033 *Glorious* and 50050 *Fearless* race past the site of Exminster station while hauling the Meldon Quarry to Plymouth 'Atlantic Coast Express' railtour on 25 September 1993. No. 50050, the first class '50' engine to have been built, was running in BR blue livery as D400 (its original number) when the photograph was taken. Exeter can be glimpsed in the background. The wider-than-usual spacing between the up and down running lines serves as a reminder that the South Devon Railway was once a 7-foot broad gauge route.

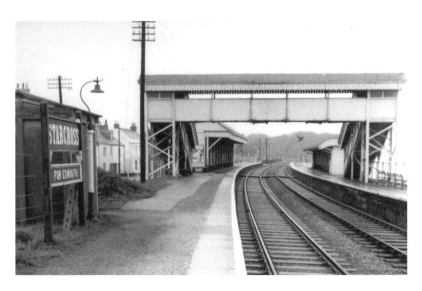

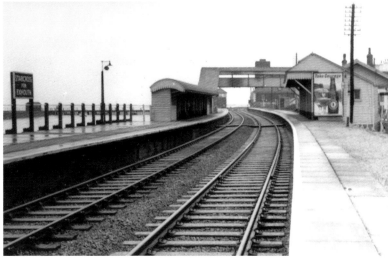

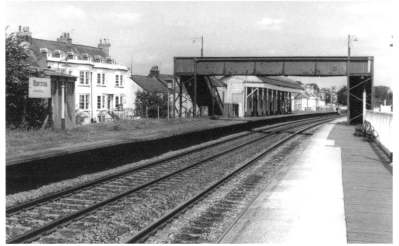

Starcross

Above left: Starcross, the next station (202 miles 35 chains), was opened by the South Devon Railway on 30 May 1846. Prior to rationalisation, its facilities included a wooden station building on the up side and an open-fronted waiting shelter on the opposite platform, but both platforms are now equipped with modern waiting shelters; at high tide, the water laps the rear of the down platform. The photograph, taken during the 1960s, is looking north towards Paddington. *Above right*: A general view, looking south from the up platforms during the early 1960s. The tower of Brunel's Starcross pumping station can be glimpsed in the background; this was part of the Victorian engineer's ill-fated atmospheric railway. *Right*: A further view of Starcross station, looking north from the down platform during the 1960s.

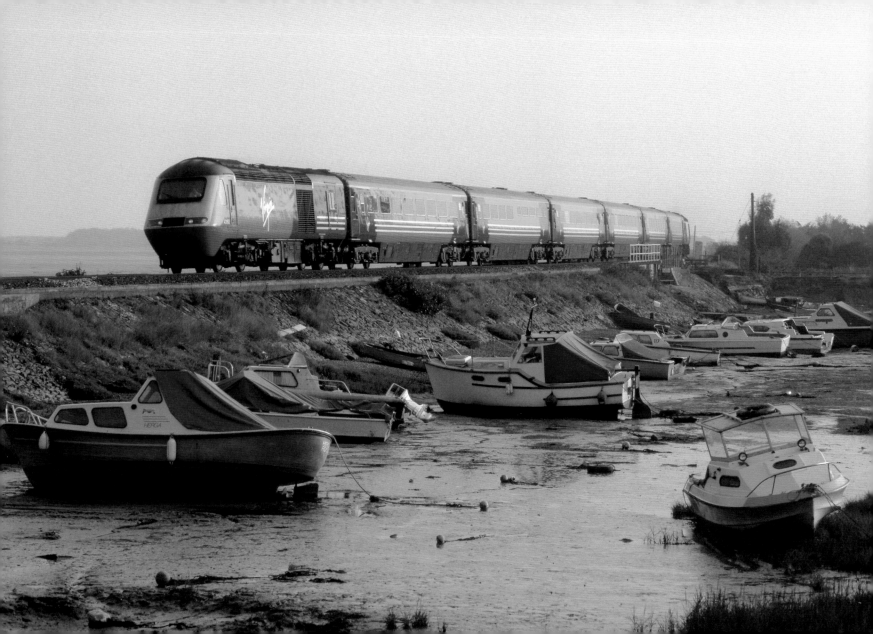

Starcross – Beside the Exe

Above left: Class '150' unit No. 150232 approaches Starcross with the 1.54 p.m. Exmouth to Plymouth service on 29 June 2002; the tidal River Exe can be glimpsed in the background. *Above right*: Sister unit No. 150248 passes Cockwood Harbour with the 2.14 p.m. Exeter Central to Paignton service in autumnal sunlight on 1 November 1997. *Below*: The view from a southbound train, taken by Mike Marr on 28 August 1974.

Opposite: Starcross – Passing Cockwood Harbour

HST power car No. 43160 is illuminated by the final rays of the setting sun as it takes the 2.30 p.m. Paignton to Newcastle Virgin Cross Country service northwards past Cockwood Harbour on 1 November 1997. This picturesque tidal inlet, to the south of Starcross station, was an ideal location for lineside photography, although it has now been spoiled by the addition of an obtrusive fence along the embankment.

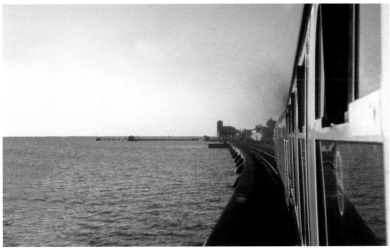

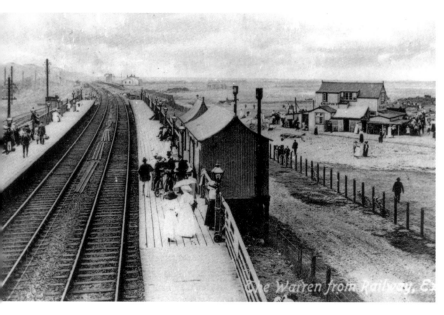

Left: Dawlish Warren

Following the widening estuary, the route continues south towards Dawlish Warren (204 miles 37 chains), where trains finally reach the open sea. Opened as Warren Halt on 1 July 1905, this station was initially equipped with simple pagoda buildings, as shown in these two photographs, but improved facilities were provided when the station was resited in September 1912. In its later incarnation, Dawlish Warren boasted a spacious, quadruple-track layout, together with a small goods yard.

Right: Dawlish Warren

This *c.* 1910 postcard view shows a GWR steam railmotor car and trailer standing alongside the down platform of the original Warren Halt. This first station was sited 17 chains (a little under ¼ mile) to the south of the present station.

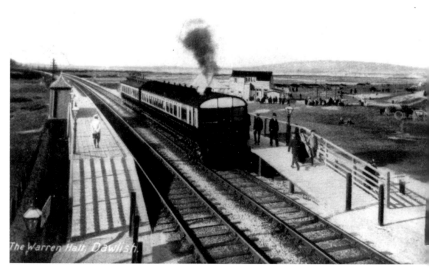

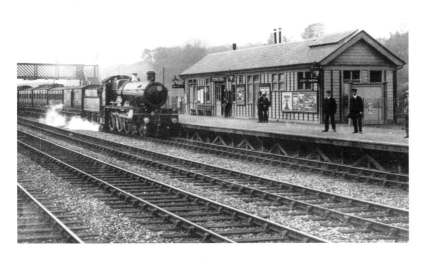

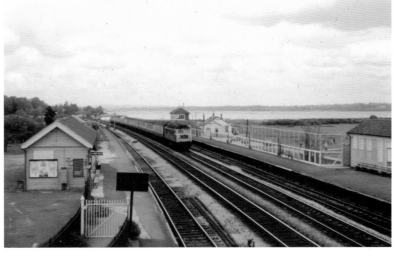

Dawlish Warren

Above left: The rebuilt station was provided with timber-framed station buildings, while the goods yard, which had four dead-end sidings, was situated to the south of the platforms on the up side of the running lines. The photograph shows an unidentified 'Saint' class 4-6-0 entering the station with an up stopping train during the early years of the twentieth century. *Above right*: A general view of the station, as it appeared in 1973. An unidentified class '47' locomotive is heading southwards with a down passenger working. *Right*: A detailed view of the main station building in 1973. Internally, this single-storey building contained the usual range of accommodation, including a ticket office, waiting room and toilets for both sexes.

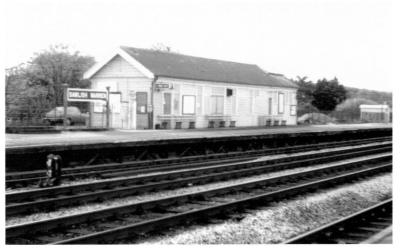

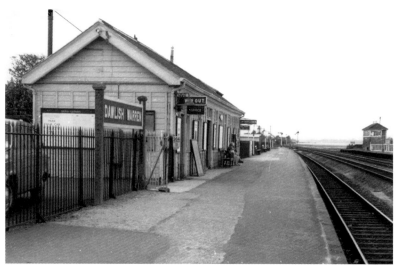

Dawlish Warren

Left: A further view of the main station building, looking northwards along the up platform around 1963. This building was burned down in 2003, and a private residential property was subsequently erected on the same site; this new structure was designed to look like a standard Great Western hip-roofed signal cabin. The up and down platforms are now equipped with simple, bus-stop-style waiting shelters. *Below left*: The north end of the up platforms, with the signal cabin visible to the right. *Below right*: A detailed view of the signal box, which was sited at the north end of the down platform. This cabin was a standard Great Western hip-roofed box, dating from 1911.

Opposite: Dawlish

Having passed through a short cutting at Langstone Rock, trains emerge onto the sea wall; the photograph, taken on 29 June 2002, shows class '47' locomotive No. 47829 approaching Langstone Rock with the northbound 8.48 a.m. Penzance to Manchester Piccadilly Virgin Cross Country service.

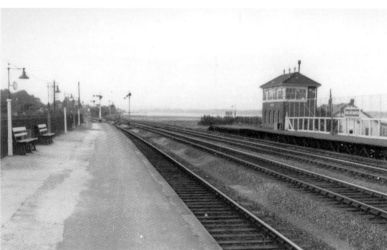

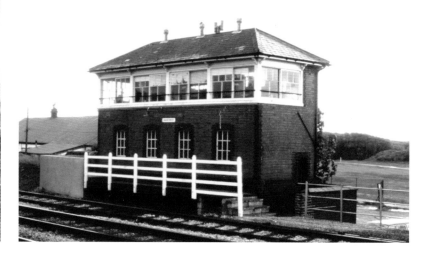

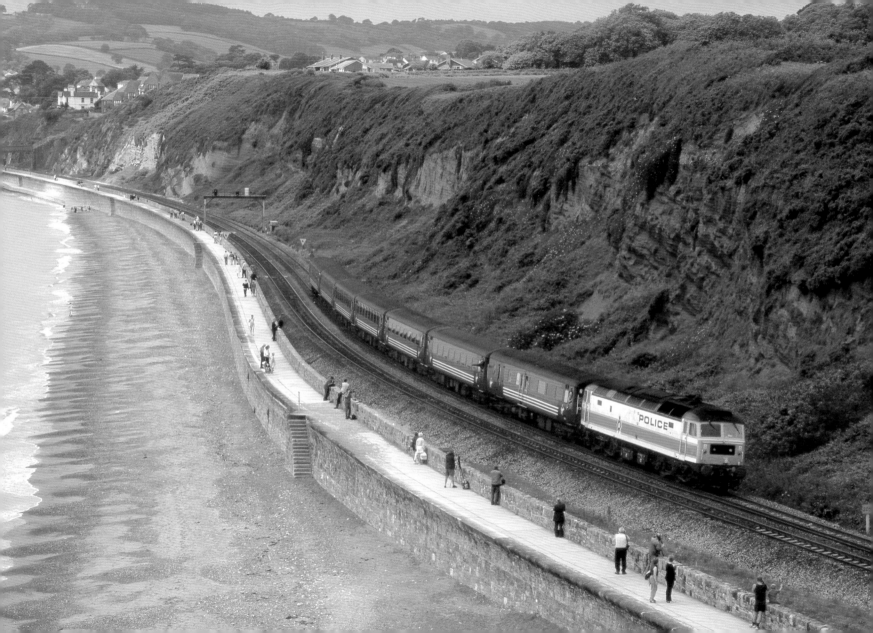

Dawlish

Left: Dawlish station (206 miles 9 chains) was opened on 30 May 1846. Its facilities consisted of up and down platforms for passenger traffic, together with a goods yard on the up side. The yard contained two sidings and a much shorter spur, the goods shed siding being arranged as a loop with connections at both ends, whereas the adjacent mileage siding was a dead-end siding. The yard was equipped with loading docks, cattle pens and a 6-ton yard crane, which can be seen in this panoramic view of the station and beach. *Below left*: An Edwardian postcard showing passengers waiting on the up platform while a steam railmotor car runs into the station. The main station building is on the up platform, and there is a subsidiary building on the down side. *Below right*: An old postcard view, looking north towards the station from Lea Mount.

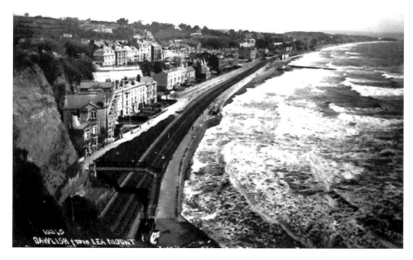

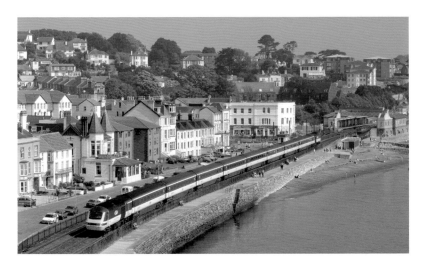

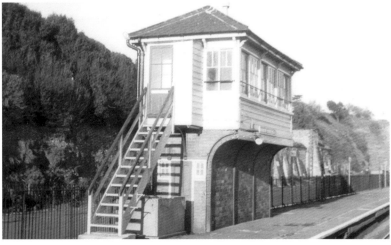

Dawlish

Above left: HST power car No. 43126 heads a complete rake of matching Great Western trains stock through the station while working the 8.33 a.m. Paddington to Plymouth 'Mayflower' service on 3 May 1999. The dark green and off-white livery was adopted following privatisation on 4 February 1996. *Above right*: Dawlish signal box was opened in September 1920 to replace an earlier cabin that had been sited on the down platform. *Below right*: A rear view of the signal box, taken by Mike Marr in May 1983.

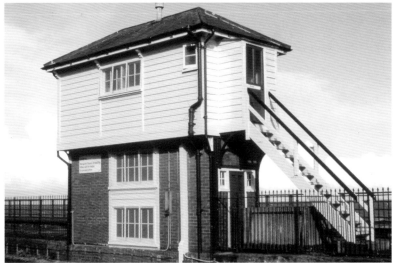

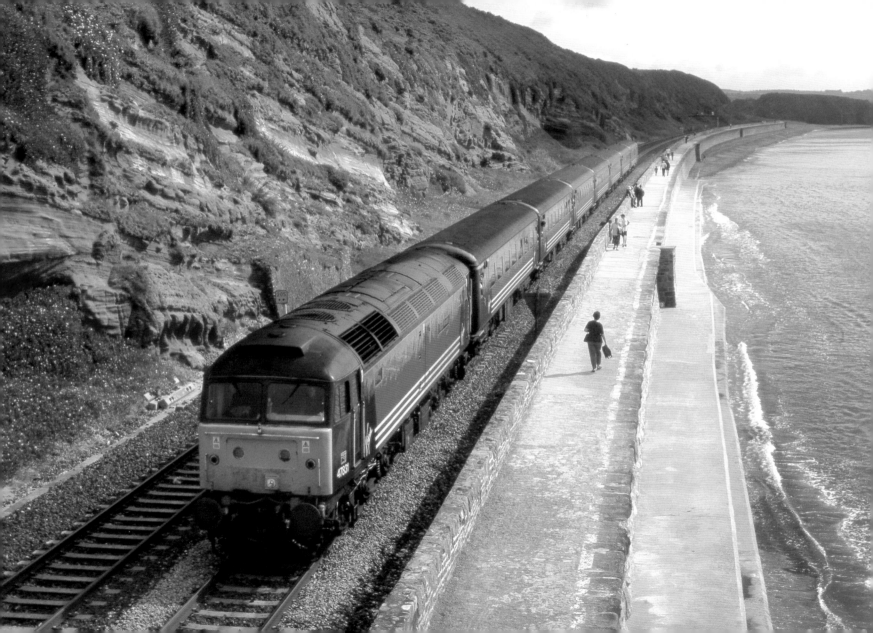

Dawlish

Right: A general view of the station, looking north-east towards Paddington during the early 1960s. Dawlish has retained most of its Victorian infrastructure, although the goods yard sidings were taken out of use in 1965. *Below left*: This early twentieth-century postcard view is looking south-westwards in the opposite direction. The bridge that can be seen in the foreground is known as Colonnade Viaduct, and it has a length of 39 yards. *Below right*: A similar view, looking south-west towards Penzance on 26 July 1973. The locomotive is class '52' No. D1048 *Western Lady*. Kennaway Tunnel can be seen in the distance.

Opposite: Dawlish

Class '47' locomotive No. 47831 *Bolton Wanderer* passes the distinctive red sandstone cliffs as it approaches to Dawlish with the 7.00 a.m. Bristol Temple Meads to Paignton Virgin Cross Country service on 29 June 2002. Virgin replaced its class '47' fleet with 'Voyager' units a few weeks after this photograph was taken.

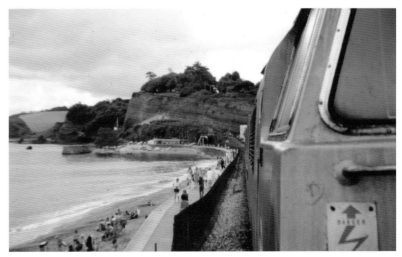

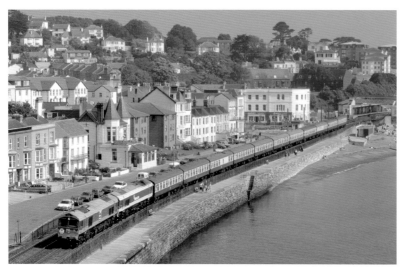

Dawlish

Left: Class '59' locomotive No. 59001 *Yeoman Endeavour* and sister locomotive No. 59103 *Village of Mells* pull away from the station with the 7.52 a.m. Bristol Temple Meads to Paignton Mendip Rail 'English Riviera Special' railtour on Bank Holiday Monday 3 May 1999. This was the annual railtour for Mendip Rail staff. With 6,600 hp and 227,100 lb of tractive effort available, there were no problems with haulage capacity here, an eleven-coach train being a modest load for even a single class '59'! *Below left*: Another postcard view, looking north from Lea Mount during the early years of the twentieth century. *Below right*: Looking south-westwards from the footbridge during the mid-1950s.

Opposite: Dawlish

HST power car No. 43155 *City of Aberdeen* leads the 6.05 a.m. Leeds to Plymouth Virgin Cross Country 'Armada' service past Dawlish on 3 May 1999. No. 43155 had received its *City of Aberdeen* nameplates at the eponymous station in June 1998, having had its previous *The Red Arrows* plates removed on the previous day. This particular power car has had its fair share of different names, having also been known as *BBC Look North* between 1985 and 1990.

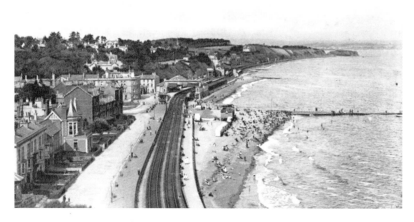

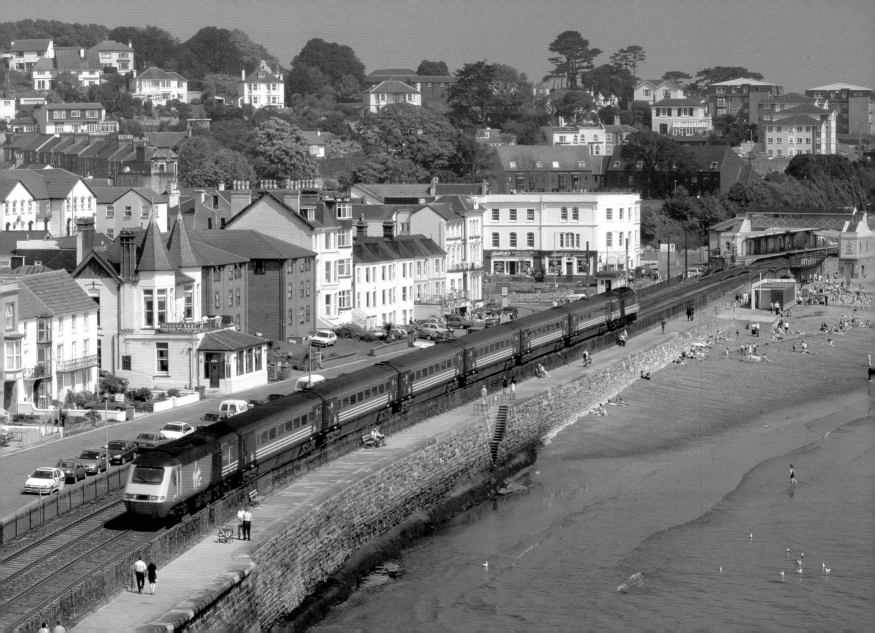

Teignmouth

Left: On leaving Dawlish, trains enter Kennaway Tunnel, some 205 yards in length, beyond which the South Devon main line skirts Coryton Cove Beach before passing through the 227-yard Coryton Tunnel. Continuing south-westwards, down workings pass through two short tunnels in quick succession; Phillot Tunnel is 49 yards long, while Clerk's Tunnel has a length of 58 yards. To the left, travellers are rewarded with glorious views of the sea in all its moods, while at high tide the waves sometimes break over the railway. *Below left & below right*: These two photographs, taken in July 1973, show trains heading southwards along the sea wall on this iconic stretch of the Great Western main line.

Opposite: Teignmouth

HST power car No. 43032 *The Royal Regiment of Wales* leads the 12.45 p.m. Paignton to Paddington service along the sea wall near Teignmouth on 25 May 1996.

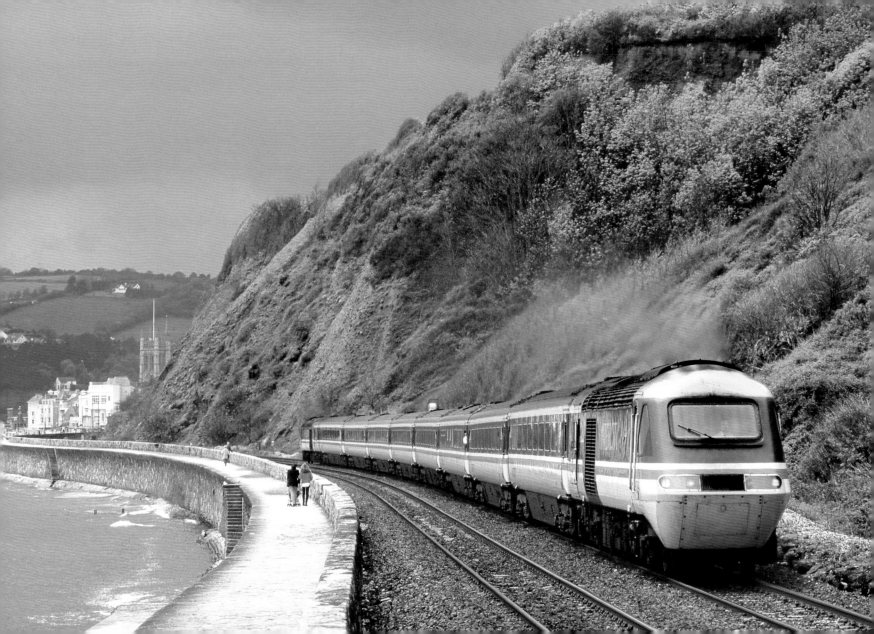

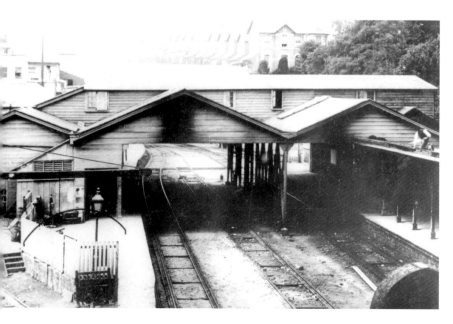

Left: Teignmouth – The Old Station

Opened by the South Devon Railway on 30 May 1846, Teignmouth (208 miles 75 chains) was originally equipped with wooden station buildings and barn-like train sheds, as shown in this Victorian photograph. The station is situated on a somewhat restricted site, with the town to the south and retaining walls immediately to the north of the platforms. There were originally three lines between the platforms – a third line or loop siding having been inserted between the up and down running lines. However, when the station was reconstructed in 1884, the third line was abolished in order to make sufficient room for wider platforms.

Right: Teignmouth – The Rebuilt Station

This Edwardian postcard scene shows the enlarged and much improved post-1884 station. Despite the relative importance of Teignmouth as a holiday destination, only two platforms were ever provided, although these are both of ample length in relation to present-day HST sets, the down platform having been extended on at least two occasions, so that it is now much longer than its counterpart on the up side.

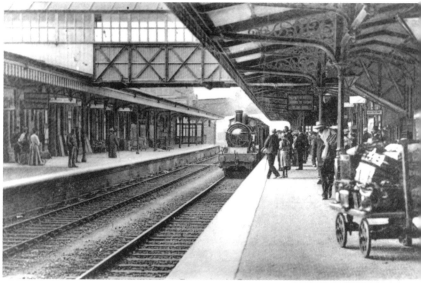

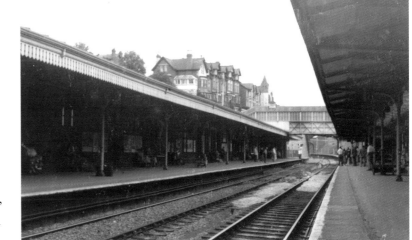

Teignmouth

Right: A view of Teignmouth station during the 1960s, looking north along the down platform. The buildings here are of standard Great Western design, with hipped roofs and extensive platform canopies. *Below left*: The up platform, looking north during the early 1960s. *Below right*: A detailed view showing the north end of the attenuated down platform.

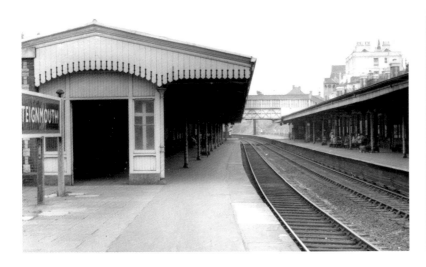

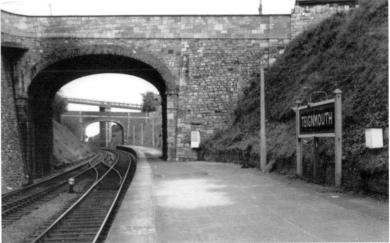

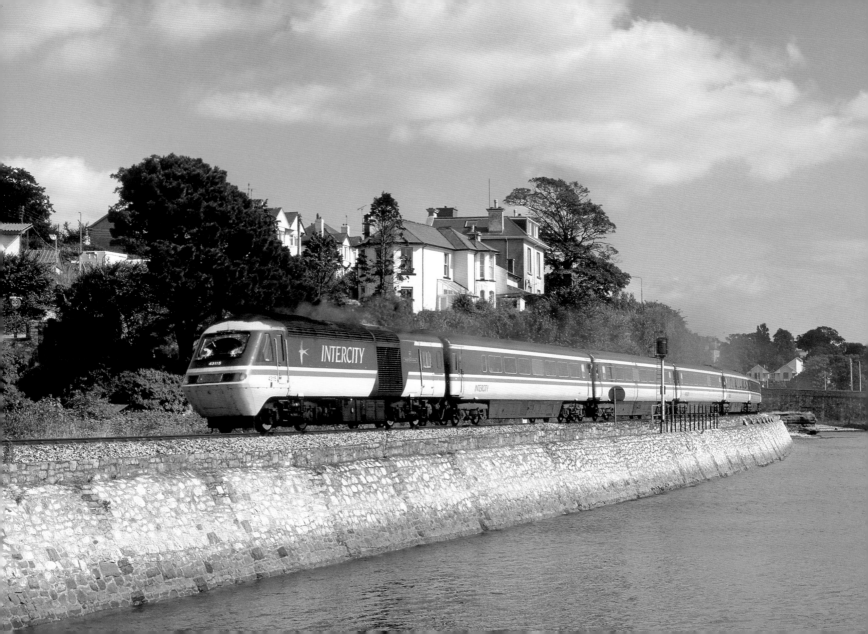

Newton Abbot – The Victorian Station

When opened on 31 December 1846, Newton Abbot (214 miles 6 chains) had boasted one of Brunel's curious single-sided station layouts, with two wooden train sheds for up and down traffic. A third shed was erected when the Torquay branch was opened in 1848, while a decorative Italianate engine house was built in connection with the ill-fated 'atmospheric' propulsion system. The original station had a very short life, and in February 1860 it was reported that a new station would be constructed at a cost of £10,000, the contractors being Messrs Call & Pethick. When brought into use in the following year, the new station featured a much larger overall roof, together with two smaller train sheds. There were two main platform lines for up and down traffic, while a third or middle line ran through the centre of the station. Three narrow platforms were provided, each with a length of 400 feet, the platforms being arranged in such a way that the up main and centre platform lines were, in effect, through bays, with platform faces on both sides.

In the event, the rebuilt Newton Abbot station soon became a severe bottleneck on the busy West of England main line, its somewhat limited facilities being inadequate to deal with increasing amounts of holiday traffic to Torbay and other destinations. It was therefore decided that the station would be enlarged and reconstructed, with new facilities for both goods and passenger traffic, the first stage being the construction of an improved goods depot, together with additional marshalling sidings on the down side of the main line at Hackney.

The new goods station was opened in June 1911, while Hackney yard was ready for use by the following December. Work on the new passenger station commenced in 1914, but further progress was halted following the outbreak of the First World War. A revised scheme was drawn up after the war, and on Monday 11 April 1927 a spacious new station was formally opened by Lord Mildmay of Flete. The pictures on this page show the station as it existed around 1912, with the overall roof still in place.

Opposite: Teignmouth – Passing Shaldon Bridge

An HST set led by power car No. 43115 *Yorkshire Cricket Academy* rounds the curve beside the River Teign at Shaldon Bridge as it accelerates away from Teignmouth station with the 9.20 a.m. Paddington to Plymouth service on 15 September 1991.

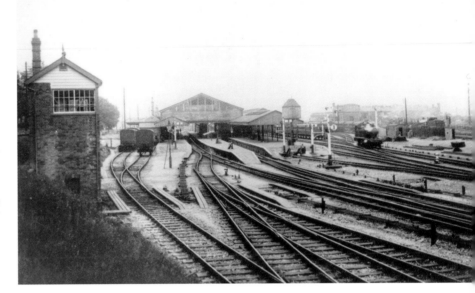

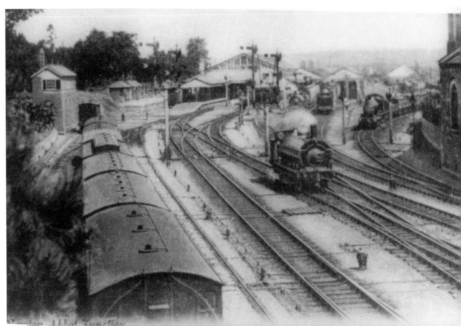

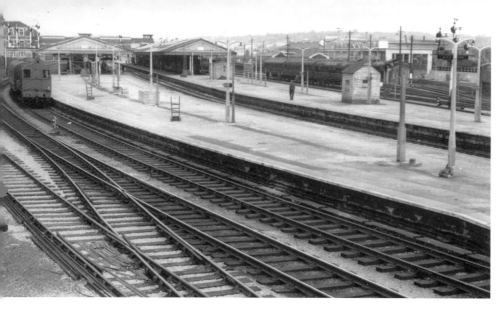

Newton Abbot – The Rebuilt Station

Above: In its rebuilt form, Newton Abbot station incorporated two very wide island platforms, with additional dead-end bays for parcels traffic on the up side, and a separate bay platform for Moretonhampstead branch services. The island platforms were 1,375 feet in length; the up platform was 56 feet wide and the down platform had a width of 42 feet; the Moretonhampstead branch bay was 320 feet long, and the platforms were covered by canopies for much of their length. The new track layout provided six through lines, comprising two up and two down platform lines, together with outer bypass lines on each side. The outer platform lines were linked to the adjacent bypass lines by scissor crossovers, which enabled two trains to be handled independently in each platform, while the through platform faces were divided into two by intermediate signals.

The platforms were numbered in logical sequence from 1 to 9, the two sides of the down island platform being numbered consecutively from 1 to 4, while the up island constituted platforms 5 to 8, and the Moretonhampstead bay on the west side of the station was designated Platform 9. A fully enclosed footbridge provided pedestrian access between the eight main platform faces, but passengers gained access to the physically isolated Moretonhampstead branch platform by means of a separate entrance at the side of the station building. *Below*: A glimpse of the main up side station building prior to reconstruction.

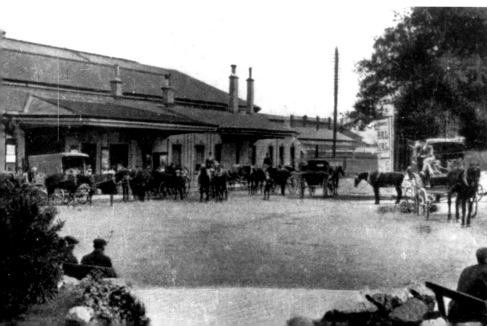

Newton Abbot – The New Station Building

The rebuilt station, which was designed by P. E. Culverhouse, the chief GWR architect, featured a three-storey station building with prominent pilasters, a central pediment and a stylish Mansard roof, the resulting effect being slightly French in appearance. The building was of red-brick construction, with Portland stone dressings, while the pediment sported a large clock, which had been presented to the railway company by the townsfolk as a token of thanks for the fine new station that had been provided for them. Internally, the new building contained a range of accommodation for the travelling public, including a booking hall and ticket office on the ground floor, together with cloakrooms and a parcel office. The first floor was occupied by a spacious dining room measuring around 66 feet by 19 feet, while the second floor contained the headquarters of the Divisional Locomotive Superintendent.

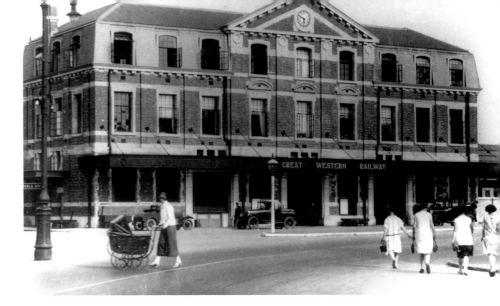

Newton Abbot – Signalling Details

The rebuilt station was signalled from two large signal cabins, which were known as Newton Abbot West and Newton Abbot East boxes. At the time of its Ministry of Transport inspection in 1930, the East Box contained '174 working levers (including 2 detonator placers), 5 spare levers, 21 spare spaces, with six permanent spaces, a total of 206'. The West Box, pictured here, contained 145 working levers (including 3 detonator placers), with 5 temporary and 3 permanent spaces, a total of 153 levers. The method of signalling employed was traditional in character, as the GWR considered that its well-tried system of manual signalling, used in conjunction with track circuiting and Automatic Train Control, was entirely sufficient for safe and efficient operation. Newton Abbot's mechanical signal boxes remained in use until the weekend of 1–4 May 1987, when control of the signalling through Newton Abbot was transferred to Exeter panel box.

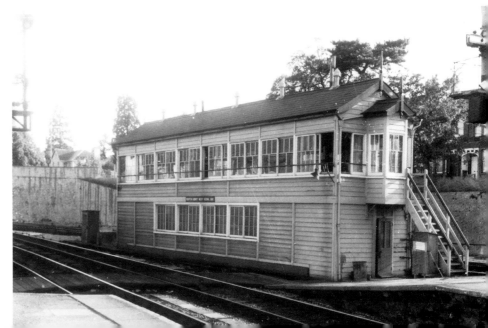

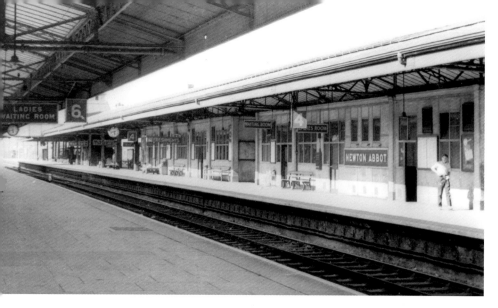

Newton Abbot – The Wartime 'Blitz'

Newton Abbot station was damaged in an air raid that took place on the evening of Tuesday 20 August 1940, when German aircraft dropped six high-explosive bombs, two of which caused severe damage to the down side station buildings, while four more bombs (one of which did not explode) hit the nearby locomotive yard. Fourteen people were killed and fifteen were severely injured, while forty-six people suffered minor injuries. Many of the casualties had been passengers aboard the 7.00 p.m. Newton Abbot to Plymouth local service, which had been standing in the down main platform at the time of the raid. Damage was caused to 51 carriages and 22 goods wagons, while 15 locomotives were also damaged – 'King' class 4-6-0 No. 6010 *King Charles I* having been strafed with machine gun fire, while 'Hall' class 4-6-0 No. 5915 *Trentham Hall*, 'Grange' class 4-6-0 No. 6801 *Aylburton Grange*, '63XX' class 2-6-0 No. 9311 and pannier tank No. 2875 sustained blast damage.

The upper photograph shows the down side station building, which was rebuilt after the war, while the lower picture is looking southwards along the eastern side of the down platform. The area of derelict land visible to the left is the site of Newton Abbot's once extensive locomotive shed and repair shops. The locomotive works was closed in 1970, although locomotive and rolling stock servicing facilities were retained until 1981.

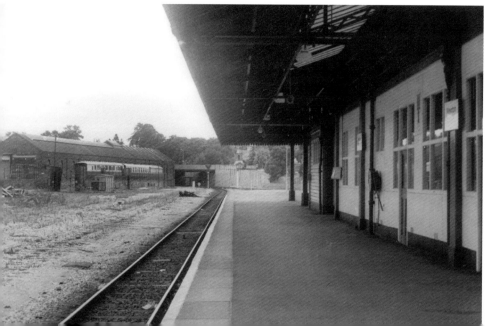

Newton Abbot – General Views

Right: A general view of the station looking north, with platforms 5 and 6 visible to the left. *Below left*: A more recent photograph, taken after the removal of platforms 7 and 8. The three surviving platforms are now numbered from 1 to 3, platforms 1 and 2 being the two sides of the easternmost island platform, while Platform 3 is the former down relief line. All three platforms are signalled for bi-directional working. *Below right*: Class '52' locomotive No. D1048 *Western Lady* stands alongside what is now Platform 1 with a down passenger working on 26 July 1973. Newton Abbot remains a busy rail centre, which, according to the Office of Rail Regulation, now handles around a million passenger journeys per annum; in 2010/11, for example, the station generated 1,021 passenger journeys, rising to 1,088 in the following year.

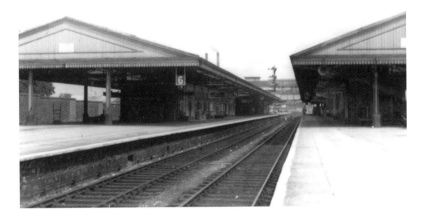

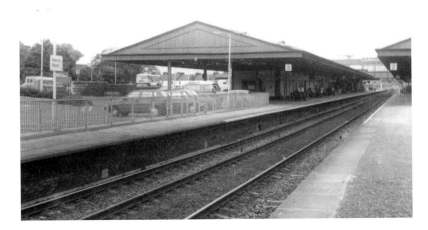

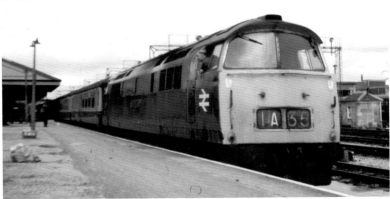

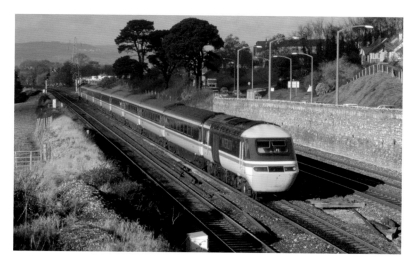

Newton Abbot – Aller Junction

When opened in 1848, the branch to Torre (then known as Torquay) was worked as an independent single line between Newton Abbot and Aller, but in January 1855 the SDR main line was doubled between Newton Abbot and Totnes, and the hitherto separate lines were then worked as up and down lines with a physical junction at Aller (215 miles 10 chains). This section of line was quadrupled during the 1870s and the junction was then removed, although a signal box was still required in connection with the working of the nearby Aller siding. Further changes ensued in 1925 when a new Aller Junction Signal Box was opened and the junction was reinstated, though as a result of more recent changes, the physical connection has again been removed, and the branch to Torquay and Paignton is now worked as an independent double-track line between Newton Abbot and Aller – in effect, a reversion to the pre-1925 situation.

The upper picture shows an HST set led by power car No. 43145 passing Aller with the 10.10 a.m. Paddington to Plymouth service on 7 December 1988, while the lower view shows class '66' locomotive No. 66076 approaching Aller with the Wessex Trains 'Wessex Eclipse Express' railtour on 11 August 1999. This working was one of a number of special trains that travelled down to the West Country to allow people to view the total solar eclipse, which could only be fully appreciated in Devon and Cornwall.

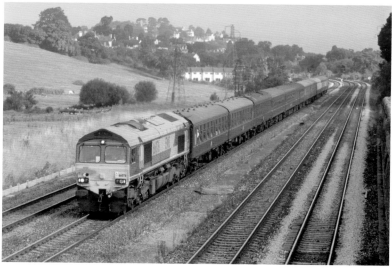

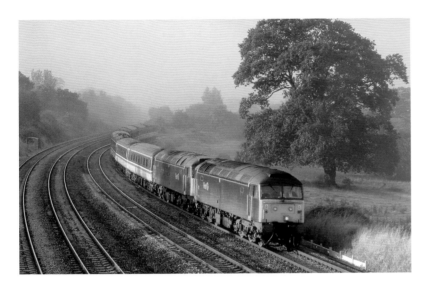

Right: Newton Abbot – Aller Junction

Hybrid two-car multiple unit No. P872 comprising Metro Cammel class '101' motor brake second No. 53247 (formerly No. 50247) and class '108' motor composite No. 53646 (formerly No. 50646) passes Aller while forming the 12.45 p.m. Exmouth to Paignton service on 7 December 1988. This was an interesting route for a local service, which ran from one seaside resort to a another, requiring an intermediate reversal at Exeter St Davids. Laira-based set P872 was one of the many hybrid DMU formations in use at that time; however, it had a comparatively short life in this form, as No. 53247 was withdrawn in the late 1990s and cut up by Mayer Newman of Snailwell, near Newmarket, while No. 53646 soldiered on for a couple more years before being scrapped at Gwent Demolition in May 1992.

Left: Newton Abbot – Aller Junction

Green liveried class '47' locomotives Nos 47811 and 47816 *Bristol Bath Road Quality Approved* break through the early morning fog at Aller at the head of the 4.00 a.m. Laira carriage sidings to Exeter St Davids empty coaching stock working on 11 August 1999.

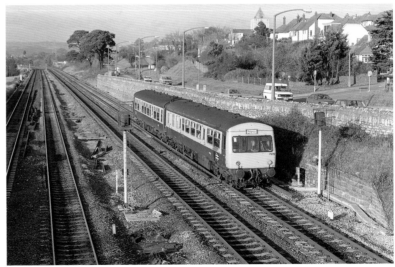

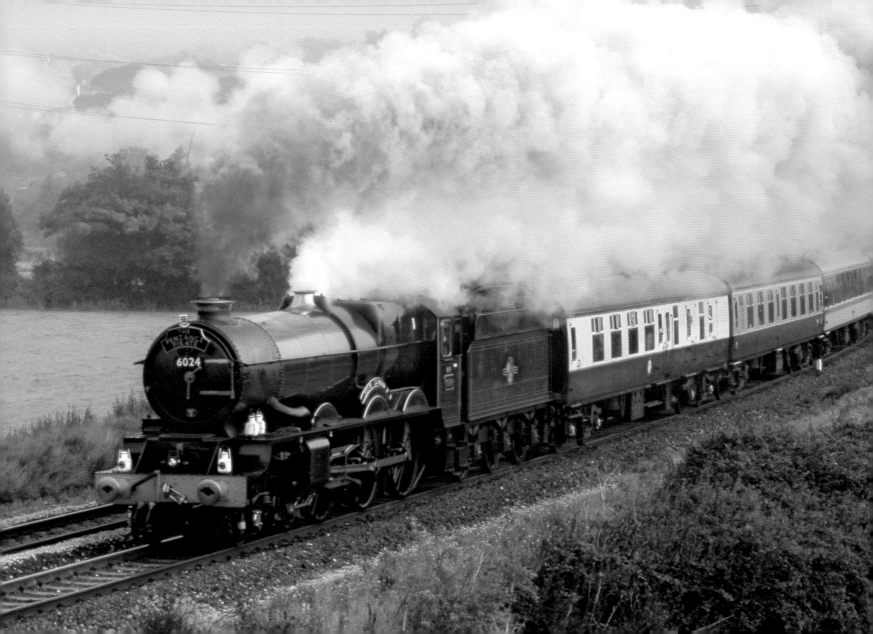

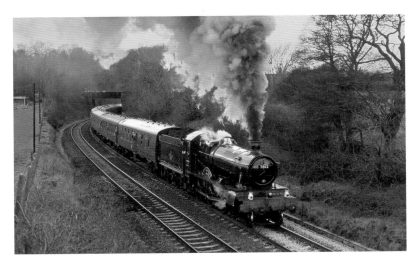

Dainton Summit – Steam & Diesel

Aller Junction marks the start of the most severely graded section of line between Paddington and Penzance. The 291-yard Dainton Tunnel (217 miles 64 chains) is preceded by over 2 miles of rising gradients, the steepest being at 1 in 41 and 1 in 36, after which the route drops towards the Dart Valley on falling gradients as steep as 1 in 37. *Above*: Moving at barely more than walking speed, 'Manor' class 4-6-0 No. 7802 *Bradley Manor* makes a tremendous effort as it hauls the 1.34 p.m. Pathfinder Tours Totnes to Worcester Shrub Hill 'Dart-Exe Cursion' railtour up the formidable 1 in 37 gradient on 16 March 1996. Although class '47' No. 47712 was assisting at the rear, the diesel appeared to be doing little more than adding to the weight! *Right*: This photograph, taken a few hours earlier, shows class '47' locomotive No. 47712 *Dick Whittington* emerging from Dainton Tunnel with the outward working from Ealing Broadway to Totnes.

Opposite: Newton Abbot – A 'King' at Aller Junction

'King' class 4-6-0 No. 6024 *King Edward I* rounds the sharp curve at Aller with the 5.30 a.m. Pathfinder Tours Paddington to Penzance 'Penzance Pirate' railtour on 19 September 1998.

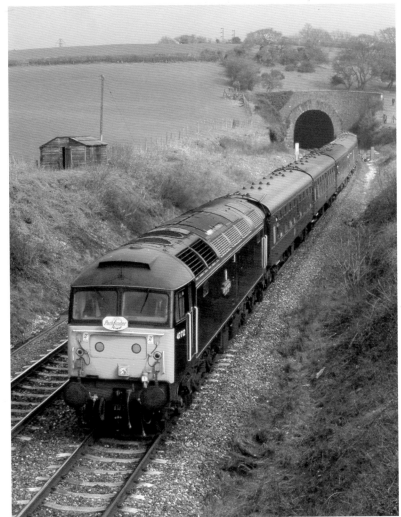

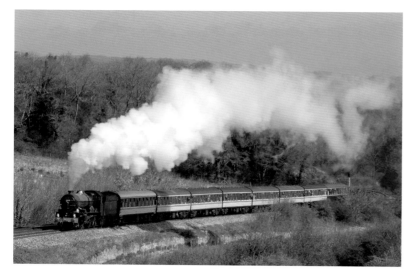

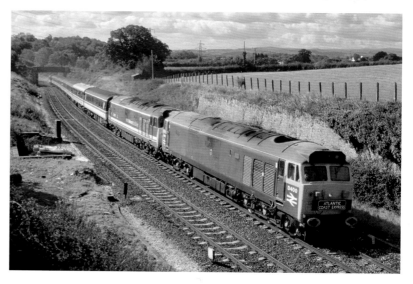

Left: Dainton Summit

'King' class 4-6-0 No. 6024 _King Edward I_ lives up to the tour's name as it climbs Dainton Bank with the 6.29 a.m. Pathfinder Tours Birmingham International to Plymouth 'King of the Banks' railtour on 5 April 1997.

Right: Dainton Summit

Class '50' locomotives Nos 50050 _Fearless_ (running as No. D400) and 50033 _Glorious_ make light work of the notorious Dainton Bank as they approach the summit with the BR sponsored Plymouth to Meldon Quarry 'Atlantic Coast Express' railtour on 25 September 1993. With 5,400 hp available, the two locomotives had no difficulties in hauling their eight-coach train up the 1 in 37 incline.

Totnes

Opened on 20 July 1847, Totnes (226 miles 66 chains) was the junction for the Ashburton branch, which was opened by the Buckfastleigh, Totnes & South Devon Railway on 1 May 1872. The station had a fairly simple two-platform layout, with up and down centre lines for through traffic between the outer platform lines, while the Ashburton line diverged north-westwards from a junction sited immediately to the north. The goods shed, of typical Brunelian design, was situated to the north of the platforms on the down side, while the cattle pens and coal wharves were served by another group of sidings at the south end of the down platform. Additional sidings were available on the up side, and a short branch ran down to Totnes Wharf.

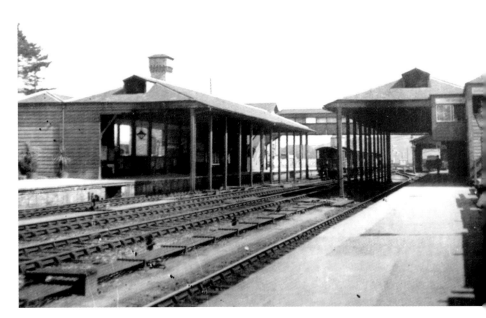

The upper photograph shows the wooden train sheds that were once provided on both sides, while the lower view is looking north from the footbridge, probably during the early 1920s. The single slip visible in the foreground gave access to the down platform loop, while the goods shed can be seen to the right of the picture.

Totnes station has seen more than its fair share of accidents and incidents. On 21 October 1942, for instance, the station was bombed by the Luftwaffe, and two people were killed in an Ashburton branch train that was in the platforms at the time of the attack. The down side station building was badly damaged by fire on 14 April 1962, while the footbridge was hit by a crane during track renewal operations on 18 October 1987. The present down side building was opened on 21 October 1983 to replace the temporary buildings that had been in use since the fire.

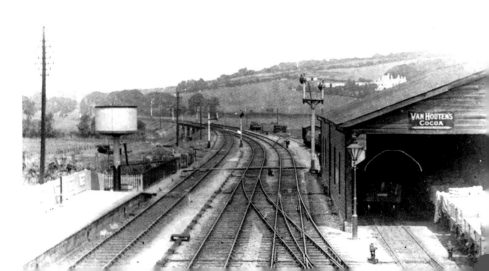

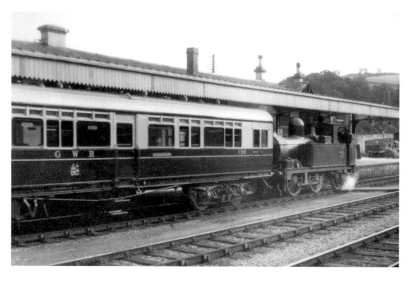

Left: Totnes – The Ashburton Branch Train

There were no bay platforms or other specific junction facilities, and for this reason Ashburton trains normally ran into the down platform and departed from the up side. The picture shows an Ashburton branch train standing alongside the down platform, probably around 1930. The locomotive is a '517' class 0-4-2T, while the passenger vehicle is auto-trailer No. 130 – a former steam railmotor. Passenger services were withdrawn from the Ashburton branch on Monday 3 November 1958, although goods traffic was carried until September 1962. After many vicissitudes, the lower section of the branch was reopened as a heritage line between Buckfastleigh and Totnes (Littlehempston), the latter station being sited a short distance to the north of the main line station.

Right: Totnes

Class '47' locomotive No. 47811 hauls the 9.18 a.m. Cross Country service from Manchester Piccadilly to Plymouth through the down platform road on 26 March 1994. As this train was not booked to call at Totnes, it would normally have used the centre road, but this was occupied by an HST set headed by power car No. 43146, the HST being an empty coaching stock working en route to Plymouth Laira.

Opposite: Totnes

Class '50' locomotives Nos 50007 *Sir Edward Elgar* and 50050 *Fearless* pass through Totnes with the 1.17 p.m. from Exeter St Davids to Penzance on 26 March 1994. This enthusiasts' special was billed as a 'farewell tour' for the class '50s in mainline service.

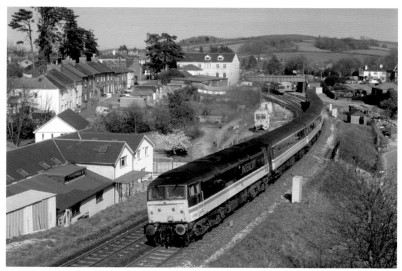

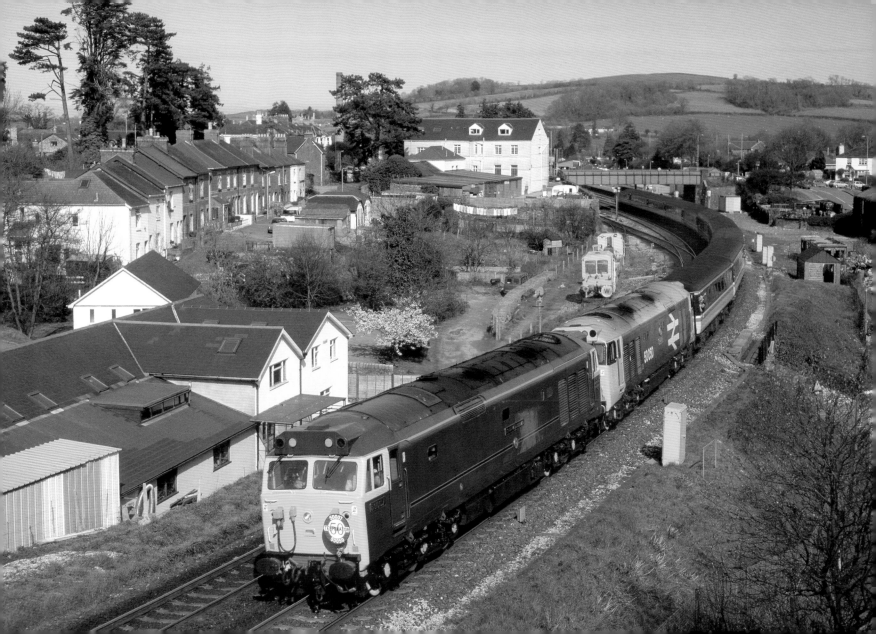

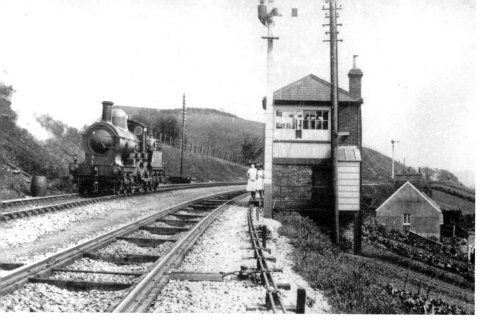

Brent

Curving onto a westerly alignment, the route climbs towards Rattery summit on a further series of adverse gradients. The line rises continuously at 1 in 46 to 1 in 56 for a distance of around 2 miles, and having passed through the 869-yard Marley Tunnel, trains soon reach Brent. The upper picture shows an unidentified 'Duke' class 4-4-0 running light engine past Rattery Signal Box (227 miles 28 chains), having assisted a heavy westbound train up Rattery Bank; note that the down line is still formed of bridge rails on longitudinal timber sleepers.

Opened on 15 June 1848, Brent (229 miles 54 chains) was the junction for branch line services to Kingsbridge. The Kingsbridge Railway was ceremonially opened on Monday 19 December 1893, while regular services commenced on 20 December, with an initial service of five trains each way between Kingsbridge and Brent. The original train service had been increased to six up and six down trains by the Edwardian period, two of these workings being mixed formations that conveyed both passenger vehicles and goods rolling stock.

Brent was a relatively spacious station, with up and down platforms for main line traffic, and an additional platform for branch trains on the down side, as shown in the lower picture. The standard Great Western station building was on the up platform, and this brick-built, hip-roofed structure contained the usual booking office and waiting room facilities, together with male and female toilets and a stationmaster's office. Facilities on the down platform consisted of a small waiting room block, which also contained staff offices and a public toilet. This building was of brick and timber construction, and it incorporated a generously proportioned canopy, which provided protection for both the main line and branch platforms.

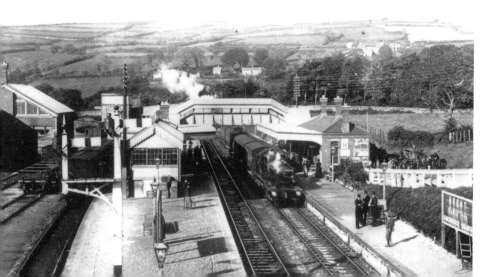

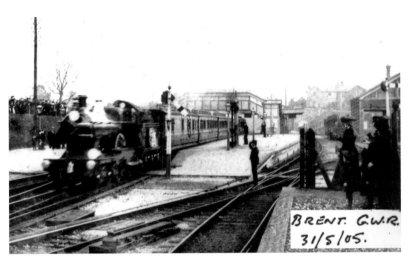

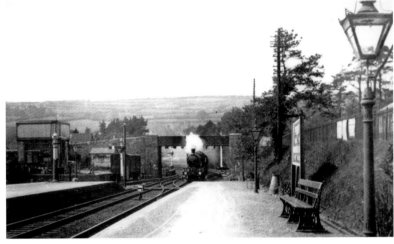

Brent

Above left: This photograph, taken on 31 May 1905, appears to show a Royal train passing through Brent. The goods yard, visible to the right, contained three long sidings and a short dead-end spur. One of the sidings served a typical late Victorian brick goods shed, while others served livestock pens and loading docks; the goods shed contained a loading platform and a 1 ton 10 cwt fixed hand crane. *Above right*: A detailed view showing the road overbridge at the east end of the station during the early years of the twentieth century. *Right*: A similar view of the road bridge, taken around 1962.

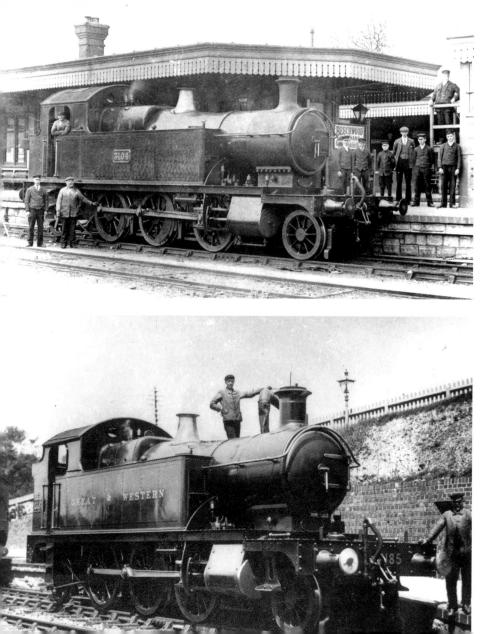

Brent – '44XX' & '45XX' Class Locomotives

In 1904, the Great Western built a prototype 2-6-2T locomotive with 4-foot 1-inch coupled wheels. This engine having proved satisfactory, ten further engines of the same general type were ordered in 1905. These engines became the '31XX' (later '44XX') class, and they operated on the Kingsbridge branch for several years, one of the first to appear being No. 3104, which is shown in the upper picture. The '44XX' class 'Small Prairies' were later joined by the visually similar '45XX' series with 4-foot 7½-inch coupled wheels, and the latter engines had become well established on the Kingsbridge line by the 1930s. One or two small prairies were normally sub-shedded at Kingsbridge, the local allocation in 1921 being '44XX' class engine No. 4401, and '45XX' class 2-6-2T No. 4552. In 1947, at the very end of the Great Western era, the Kingsbridge-based engine was No. 55\51. Numerous '45XX' class 2-6-2Ts worked on the line throughout the years, some typical numbers, in the later Great Western and early British Railways periods, being Nos 4550, 4561, 5506, 5519, 5525, 5530, 5551, 5557, 5564 and 5573. Most of these locomotives were of the later batches, with 1,300-gallon sloping-topped tanks, though Nos 4550 and 4561 were representatives of the slightly smaller 1,000-gallon series engines, which could be easily distinguished by their flat-topped side tanks. The lower picture shows '45XX' locomotive No. 2185 at Brent around 1910; this engine was built in 1909, and became No. 4535 as part of a general renumbering scheme carried out in 1912.

Left: **Brent**
This panoramic view of Brent was taken on 1 May 1925, and it shows London & North Eastern Railway 'A3' class 4-6-2 locomotive No. 4474 *Victor Wild* passing through the station during the 1925 locomotive exchange trials.

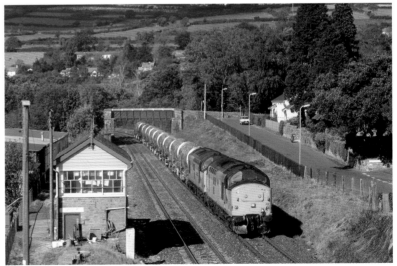

Right: **Brent**
The Kingsbridge line was closed with effect from Monday 16 September 1963, and as there were no Sunday services, the last trains ran on Saturday 10 September. Small groups of local people and enthusiasts turned up to see and photograph the final workings, and the last train carried a headboard with the legend 'LAST DAY FOR THIS BRANCH'. The abandoned branch line was lifted in the next few months, and Kingsbridge station was closed on 5 October 1964. This post-closure view shows class '37' locomotives Nos 37412 and 37671 *Tre Pol and Pen* speeding through Brent with the 9.45 a.m. Burngullow to Irvine china clay slurry tanks on 26 September 1993. These trains were known to railway enthusiasts as 'silver bullets', as their stainless steel tank wagons had yet to acquire the grime of later years. The signal box was all that remained of the erstwhile Brent station.

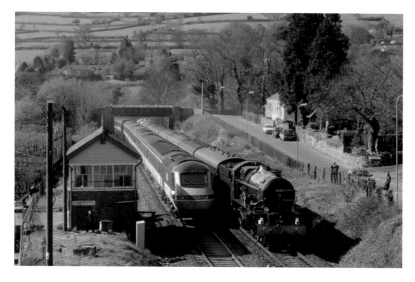

Right: Wrangaton

Situated some 2 miles to the west of Brent, Wrangaton station was opened on 5 May 1858, its original name being Kingsbridge Road. The station was situated in a deep cutting, and its infrastructure included a high-level station building in addition to the buildings at platform level. Passenger services were withdrawn on 2 March 1959, but goods traffic was handled until September 1963. The signal box, pictured here, was a standard Great Western gable-roofed cabin. The cabin is now preserved as an exhibit at Kidderminster Railway Museum.

Left: Brent

Contrasting motive power at Brent on 5 April 1997. 'King' class 4-6-0 No. 6024 *King Edward I* works the 3.05 p.m. Pathfinder Tours service from Plymouth to Birmingham International northwards through the abandoned station, while a down HST working heads in the opposite direction. The two-storey signal cabin, which can be seen to the left, was of standard Great Western design; this comparatively modern box (which had replaced an earlier timber cabin) had a brick-built lower storey and a fully glazed operating floor, with a window in the rear wall so that the signalmen could view the adjacent branch platform. The box had a gabled roof with decorative finials at each end, and a simple stovepipe chimney.

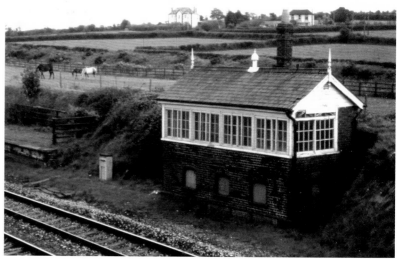

Bittaford

From Wrangaton, the line heads west-south-westwards to Bittaford – a passenger-only stopping place that was opened by the GWR on 7 November 1907 and closed on 2 March 1959. *Right*: A 'Duke' class 4-4-0 at Bittaford during the early years of the twentieth century. *Below left*: A general view of the station around 1912, showing the characteristic GWR pagoda buildings. *Below right*: A glimpse of Bittaford in the 1920s or early 1930s; note that the platforms, originally of timber, have now been rebuilt in more durable materials.

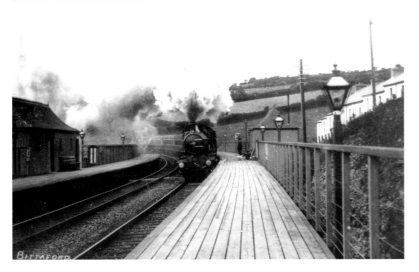

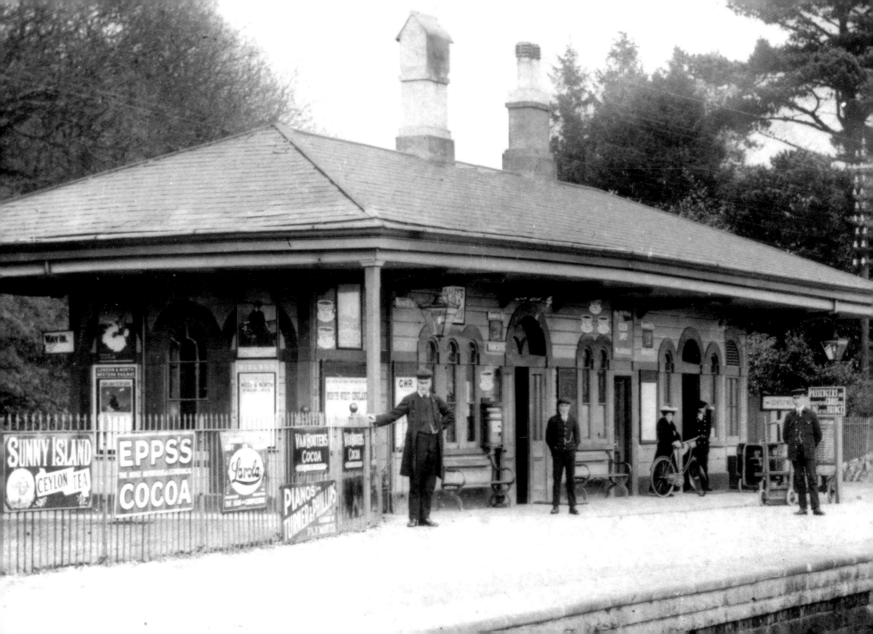

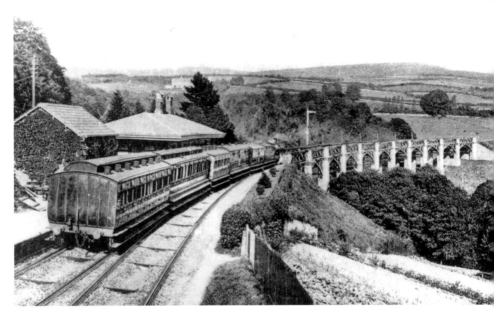

Ivybridge

Ivybridge, the next station, was opened by the South Devon Railway on 15 June 1848. Its main station building, on the up side, was of particular interest in that it was a classic Brunelian chalet-style structure, with round-headed Italianate windows and an overhanging, hipped roof. The upper picture, taken in the 1890s, is looking east towards Paddington. A broad gauge train is about to cross Ivybridge Viaduct, which was 252 yards in length and carried the railway across the Erme valley; the old viaduct was replaced by a brick and stone viaduct in 1892, but six of the original granite piers have survived beside the present bridge. Ivybridge was closed to passengers on 2 March 1959, and the lower picture shows the station after closure.

Opposite: **Ivybridge**
A detailed study of the main station building.

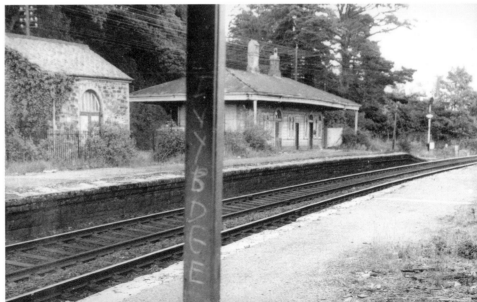

Right: Cornwood

Cornwood station was opened in 1852 and closed on 2 March 1959. Its modest facilities consisted of a standard Great Western hip-roofed station building on the up platform and a much smaller waiting room on the down side, the platforms being linked by a plate girder footbridge.

Left: Ivybridge

Ivybridge goods yard was sited to the west of the passenger station, and it contained the usual range of accommodation, including coal wharves, cattle loading pens and a 6-ton crane, together with a standard GWR goods shed, pictured here, dating from 1911. Public goods facilities were withdrawn in November 1965, but the station continued to handle china clay traffic from the nearby Lee Moor Clay pits. Ivybridge station was reopened, albeit on a new site, on 15 July 1994, and the present station has staggered platforms, which are linked by a footbridge with exceedingly long approach ramps. The new station was marketed as a 'park and ride' facility, but its initial traffic receipts were disappointing. Latterly, however, passenger usage has increased, and the station now generates around 80,000 passenger journeys per annum.

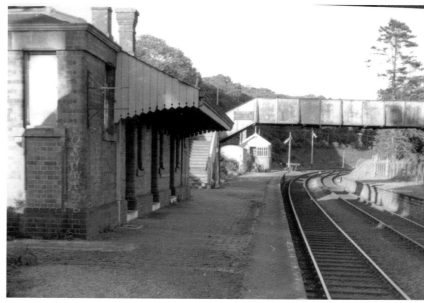

Plympton

Opened by the South Devon Railway on 15 June 1848, Plympton station, some 5 miles to the east of Plymouth, marked the edge of the Plymouth suburban area, and in the years before the First World War, Plympton residents enjoyed a service of around twenty-two trains each way, many of these services being worked by steam railmotors, some of which ran to and from Defiance Platform on the west side of the Plymouth urban area. The main station building, on the up platform, was another Brunelian chalet-style structure. In the 1920s, this comparatively small station employed eleven people, including one stationmaster, one booking clerk, one goods clerk, one parcels porter, one goods checker, three porters and three signalmen. Sadly, Plympton station succumbed to rationalisation at a relatively early date, its passenger services being withdrawn in 1959. The upper picture dates from the early years of the twentieth century, while the lower view shows Plympton in its declining years.

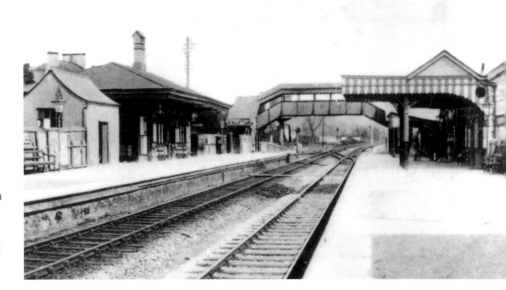

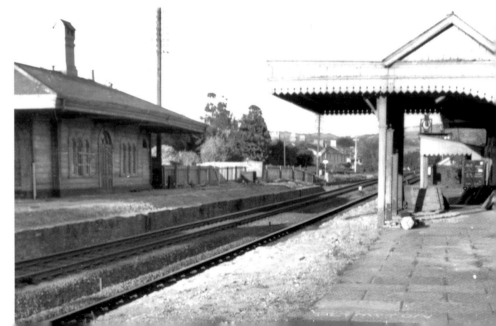

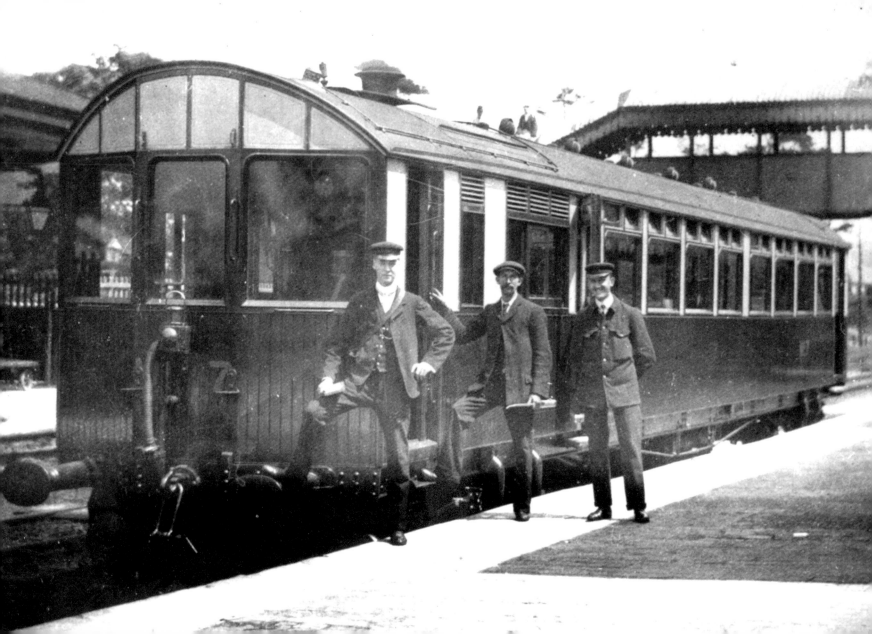

Plymouth – Laira Shed & Halt

From Plympton, trains descend towards Tavistock Junction, where the Launceston branch diverged northwards from the South Devon route. There was no station at the actual junction, although Marsh Mills, the first intermediate stopping place on the branch, was situated just 18 chains to the north of the main line. Tavistock Junction was the site of an extensive marshalling yard that was enlarged during the Second World War and further expanded during the British Railways period to provide capacity for around 2,000 wagons. The yard was at its peak during the early 1960s, but in the following decade the facilities provided here were much reduced, leaving a modest group of parallel sidings on the north side of the main line.

Continuing westwards, the South Devon main line crosses the River Plym, and with a wide estuary visible to the left, trains soon reach Laira, which remains the site of a busy motive power depot. The track layout here formerly incorporated a triangular junction, which enabled London & South Western (later SR) trains to reach their own stations at Plymouth Friary and Turnchapel. At the same time, Great Western branch services were able to reach the Yealmpton branch, which was physically detached from the GWR system and could only be reached via LSWR metals. Laira Motive Power Depot, opened in 1901, occupied a strip of land at the very top of the Laira triangle.

Laira Halt, opened as a railmotor halt on 1 June 1904, was situated on the main line immediately to the north of the engine sheds. Its modest facilities consisted of timber platforms and the usual GWR pagoda sheds. The halt was closed in July 1930. *Above*: A general view of Laira Halt. *Below*: A local train, formed of two steam railmotors and an intermediate trailer, calls at Laira around 1912.

Opposite: Plympton

Great Western steam railmotor car No. 7 poses for the camera at Plympton. This vehicle was built at Swindon in 1904 as one of a batch of six railmotors numbered 3 to 8.

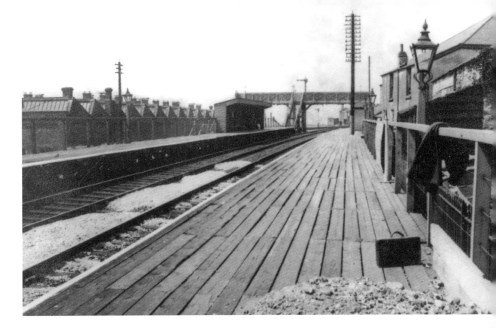

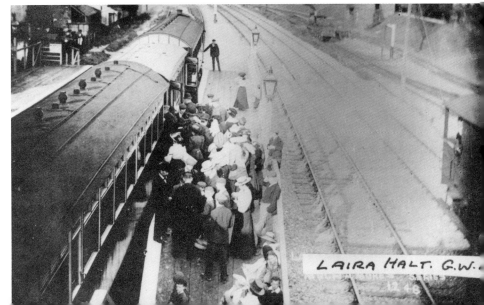

LAIRA HALT. G.W.

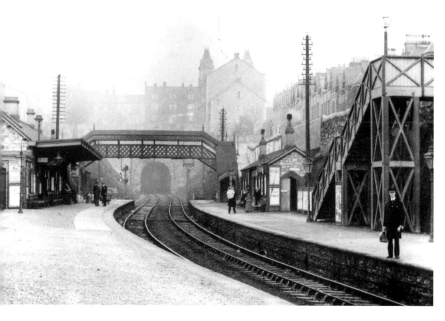

Left: Plymouth Mutley

Having passed another closed halt at Lipson Vale (closed in 1942), trains plunge into the Stygian depths of Mutley Tunnel before reaching the site of a suburban station known as Plymouth Mutley. Situated in a heavily built up area, this two platform stopping place was opened on 1 August 1877. Its main building was on the up platform, and a smaller waiting room and toilet block was available on the opposite side. The main building was a gable-roofed structure with a projecting canopy, while the up and down platforms were linked by a standard Great Western covered footbridge. Mutley was a passenger-only station, with no goods yard or loading facilities; its signal box was closed as long ago as 1908, and the signals were thereafter controlled from Plymouth North Road East Box.

Right: Plymouth Mutley

In 1903, Plymouth Mutley had a staff complement of thirteen, although the staffing establishment had been increased to seventeen by 1913. At that time, Mutley was a much busier station than North Road, with no less than 241,469 tickets being issued in 1903, rising to 364,395 by 1913. A GWR staff census carried out in 1922 shows that the station was under the control of a Class Three stationmaster, who was in charge of four booking clerks, four ticket collectors, two porters, two parcels porters, two signalmen and one charwoman (the signalmen being employed in Mannamead Signal Box, which was sited a short distance from the station on the eastern side of Mutley Tunnel).

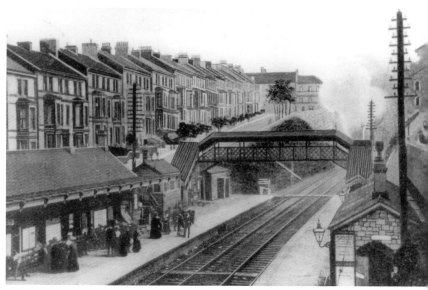

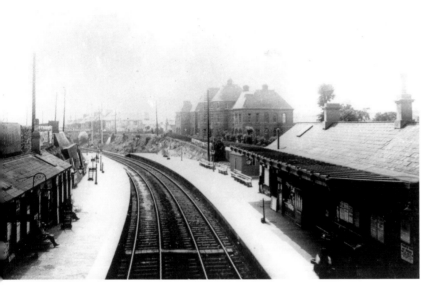

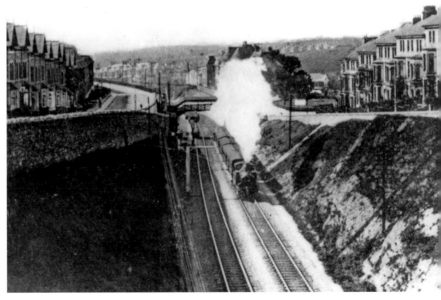

Left: **Plymouth Mutley**

Looking westwards from the footbridge during the early years of the twentieth century. Although Mutley was a purely Great Western station, a number of London & South Western services were scheduled to call. For example, the July 1883 working timetable shows that the station was then served by three L&SWR passenger trains, all of these being eastbound workings en route from Plymouth Devonport to Exeter via the Launceston branch.

Right: **Plymouth Mutley**

The staffing establishment at Mutley had been reduced to around a dozen by the end of the 1920s and seven by the following decade. By that time, passenger bookings averaged around 63,000 per annum. Mutley station was closed on the evening of 3 July 1939, in connection with the proposed remodelling of nearby North Road station. In its last full year of operation, Plymouth Mutley had issued 48,772 ordinary tickets and 554 seasons. The photograph, which is looking west towards Plymouth, appears to have been taken from one of the tall buildings above the western portal of Mutley Tunnel.

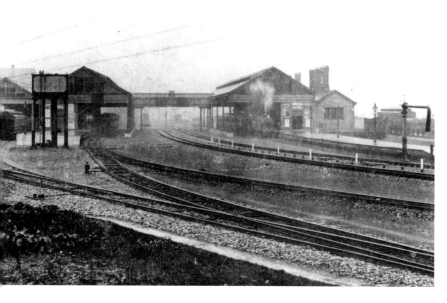

Left: Plymouth North Road – The Victorian Station

From Plymouth Mutley, trains glide westwards through cuttings for a short distance to Plymouth North Road (245 miles 76 chains). Built to plans drawn up by Peter J. Margary (1820–96), the GWR divisional engineer, Plymouth North Road station was opened in 1877. It was originally constructed of timber, its platforms being covered by an overall roof structure with a total span of 150 feet. The roof covering consisted of two gable-roof sections, each of which had a width of around 46 feet. The centre part of the station was left uncovered to facilitate smoke emission, though the three centre tracks were spanned by transverse girders that linked the twin train sheds. By the end of the Victorian period, North Road consisted of four through platforms beneath the overall roof, with additional dead-end bays on each side. The main station buildings, of timber construction, were situated on the down side.

Right: Plymouth North Road – The Old Station Building

The GWR started to rebuild the station during the 1930s, the idea being that the existing four platform layout would be remodelled, with seven through platforms and extensive new buildings. Much of the proposed platform work was completed, although further progress was halted by the outbreak of the Second World War on 3 September 1939. Plymouth was severely damaged during the ensuing conflict, and some local people claimed that the city was 'the worst blitzed' in the country (the inhabitants of Coventry and Belfast might have disagreed). North Road station was damaged by enemy action on the night of 20/21 March 1941, when a high-explosive bomb landed on the subway and brought down part of the newly erected platform covering. The photograph shows the old wooden station building during the early 1950s, by which time all but one of its decorative chimney stacks had been removed.

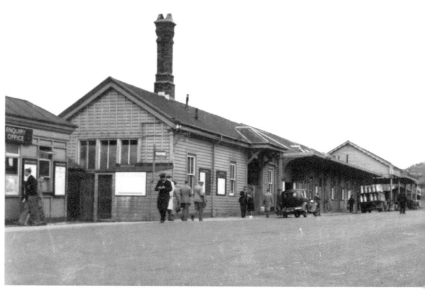

Plymouth North Road – The Rebuilt Station

In 1956, British Railways resumed reconstruction work as part of a £1 million modernisation scheme, and the new station was officially opened by Dr Richard Beeching, the chairman of the British Transport Commission, on 26 March 1962. The rebuilt Plymouth North Road station consisted of seven through platforms with additional dead-end bays for parcels and local traffic. The down side buildings were entirely rebuilt in an uncompromisingly modern style, incorporating extensive glass and concrete platform coverings and a ten-storey office block that housed the staff of the district superintendent, the district engineer and various other departments. The new tower block was accompanied by a spacious concourse, which was linked to the platforms by an underline subway. The new facilities included a booking hall, enquiry offices, waiting rooms, and the appropriately named Brunel Bar and dining room.

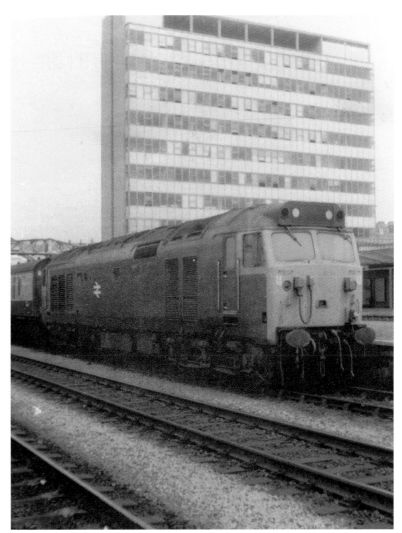

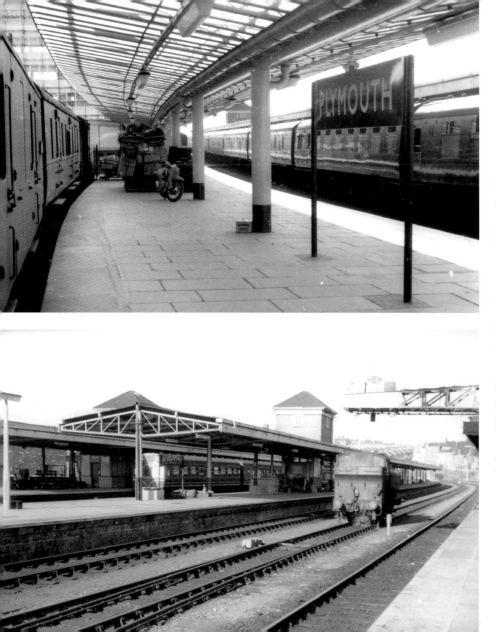

Plymouth North Road

In 1974, British Railways introduced further changes, as a result of which platforms 2 and 3, on the down side of the station, were converted into four terminal bays, leaving platforms 4, 5, 6, 7 and 8 in situ as through platforms catering for main line traffic. To facilitate this modification, a section of track in front of the main concourse was filled in and travellers were then able to walk from the concourse on to Platform 4 without passing through the subway. A truncated Platform 3, at the west end of the station, became a terminal bay for Callington branch trains, but the other bays were not numbered, as they were used mainly for parcels and mail traffic.

In its present-day form, North Road station exhibits a curious mixture of architectural styles. The unnumbered platforms in front of the ugly 1960s station buildings are covered by substantial canopies, but the other platforms are graced by lightweight canopies supported by H-girder uprights. The platform buildings include several hip-roofed, tile-hung structures, which presumably date from the earlier stages of the reconstruction scheme. Examination of the buildings on the northernmost island (platforms 7 and 8) reveals some Art Deco-style pilaster mouldings, which hint at the style of architecture that the GWR would have been adopted if the Second World War had not intervened.

The upper picture, taken in the mid-1990s, shows details of the canopy on Platform 4, with a parcels bay to the left, while the lower view is looking towards island platforms 6 and 7 during the 1960s.

Plymouth North Road – The Rebuilt Station

These two views show the eastern end of the rebuilt North Road station, the upper photograph having been taken around 1960, while the lower picture dates from March 1996. The Great Western lines around Plymouth have continued in existence as important parts of the national railway system, and although the Yealmpton and Launceston branch lines have been closed, the rebuilt North Road station handles large numbers of passengers. Present-day train services are better than those provided during the heyday of steam operation, with fast and frequent services to and from London, Penzance, Bristol, Birmingham and many other destinations.

Following privatisation, three companies operated Plymouth's passenger services. Main line services between London, Reading, Bristol and Penzance were provided by First Great Western, while cross-country services between Penzance, Plymouth and Scotland were worked by Virgin Trains. There were also a number of useful local and semi-fast services, which were operated by Wessex trains between Penzance, Bath and South Wales. At the time of writing, most services are worked by First Great Western, but the station is also served by CrossCountry workings from Scotland and the north of England, some of which continue through to Penzance.

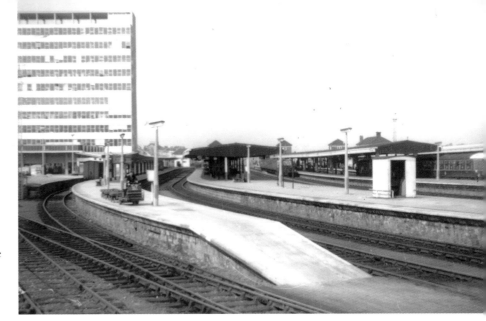

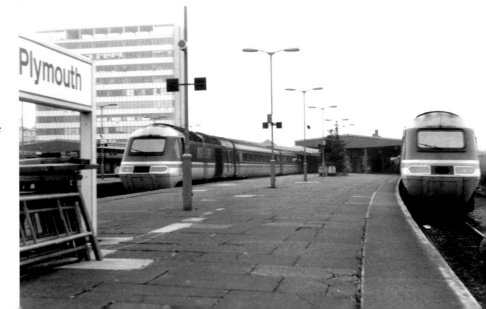

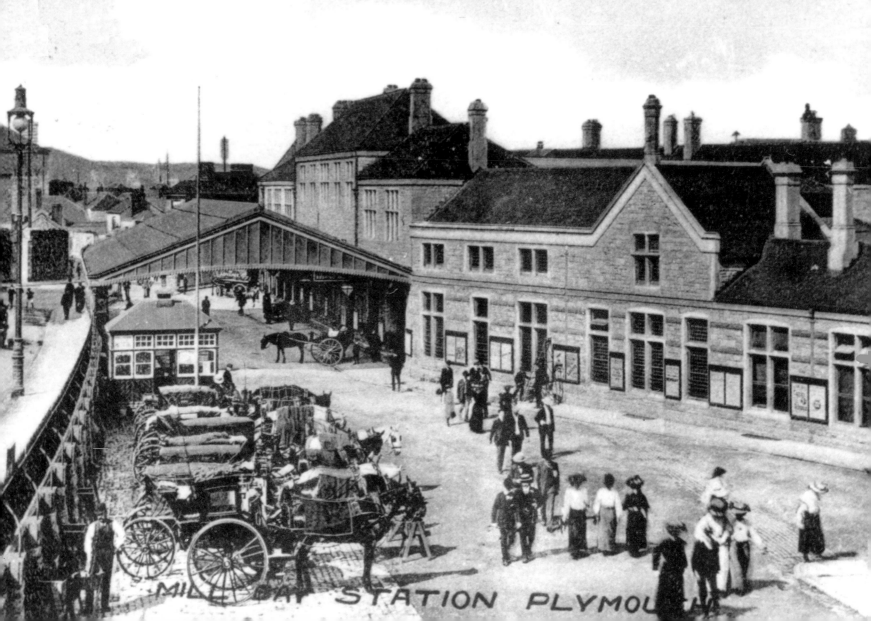

MILLBAY STATION PLYMOUTH

Plymouth Millbay

When opened throughout to Plymouth in 1848, the South Devon Railway had terminated in a temporary station at Laira Green, but this was closed on 2 April 1849, when the SDR line was extended to Plymouth Millbay. When first opened, Plymouth Millbay had been a simple wooden terminus with three platform lines beneath a train shed, and an additional platform for fish traffic on the eastern side. The station was extensively rebuilt at the end of the nineteenth century in order to provide a more modern terminus with substantial stone buildings in place of the earlier wooden facilities. There were, however, still three main terminal platforms, with a shorter bay on the east side; a proposed extra platform on the western side was never constructed. In its rebuilt form, the station lost its overall roof, but the four platforms were covered by commodious canopies. The platforms were numbered in logical sequence, Platform 1 being the short bay, platforms 2 and 3 being in the centre of the station, and Platform 4 being a longer bay on the west side of the terminus.

In October 1895, the GWR Traffic Committee proposed that £4,500 should be spent on a signalling scheme for the remodelled Millbay station, and a 117-lever signal box was eventually erected. The new cabin was inspected by the Board of Trade Inspector on 10 July 1899, at which time it contained 99 working levers. As a result of a subsequent resignalling, carried out in 1914, Millbay acquired a new 115-lever box.

Millbay's importance was diminished by the opening of Plymouth North Road in 1877, but the SDR terminus nevertheless remained in use until April 1941, when it sustained severe bomb damage. The adjacent goods depot was destroyed, and it was therefore decided that the passenger station would be closed, so that the platforms could be used for goods traffic. The station was never reopened, although empty stock workings continued to run to and from the earlier terminus, and in post-war years boat trains worked through Millbay on their way to Plymouth Docks, using a connecting line that skirted the western side of the station.

Opposite: Plymouth Millbay

An Edwardian postcard view showing the exterior of the former South Devon Railway terminus at Plymouth Millbay. This station was eventually superseded by Plymouth North Road.

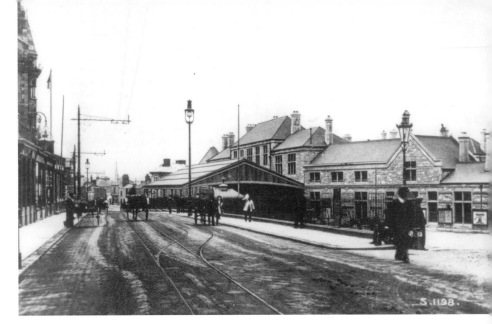

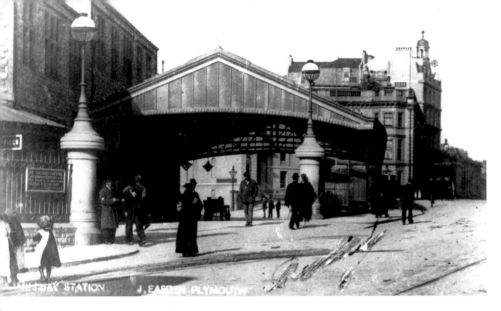

Plymouth Millbay

This final view of Plymouth Millbay station shows the elaborate *porte-cochère* that covered much of the station approach. It is interesting to note that, on 28 April 1912, the surviving crew members of RMS *Titanic* arrived in Plymouth aboard the Red Star liner *Lapland* and, after they had been interviewed by representatives of the Board of Trade, they were then allowed to return to their homes from Millbay station. The doomed liner would herself have docked at Plymouth if fate had not intervened – an 'Ocean Liner Special' run between Millbay and Paddington.

Plymouth Millbay

A selection of tickets from the western portion of the South Devon route between Dawlish and Plymouth. Great Western third-class tickets were, at one time, printed upon buff cards, but the distinguishing colour for ordinary third-class single and return tickets was later changed to green.

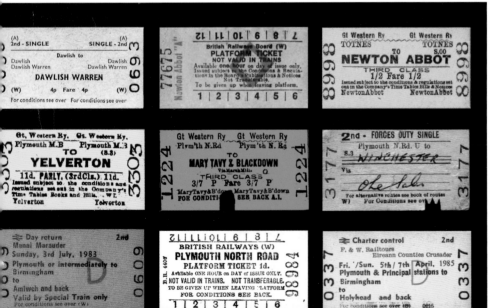